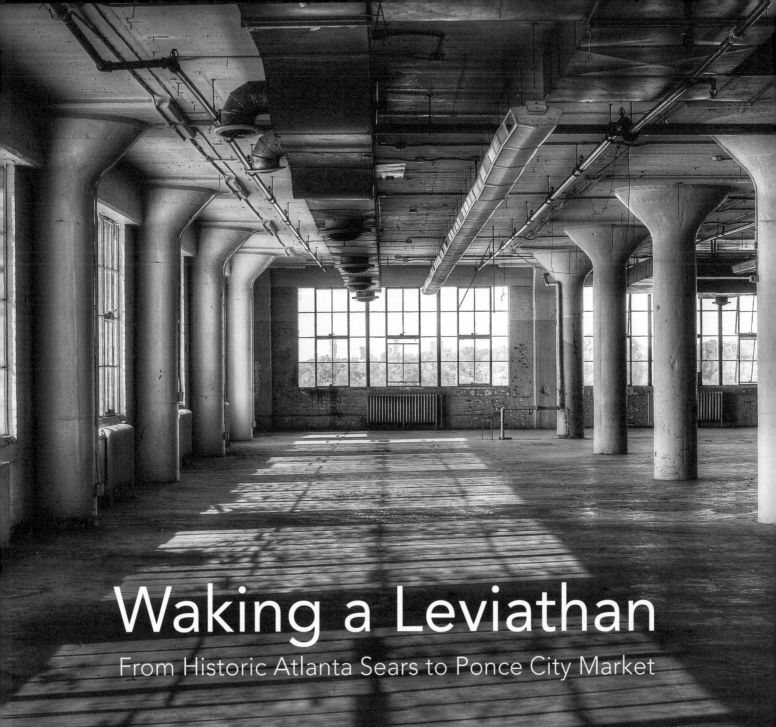

Waking a Leviathan

From Historic Atlanta Sears to Ponce City Market

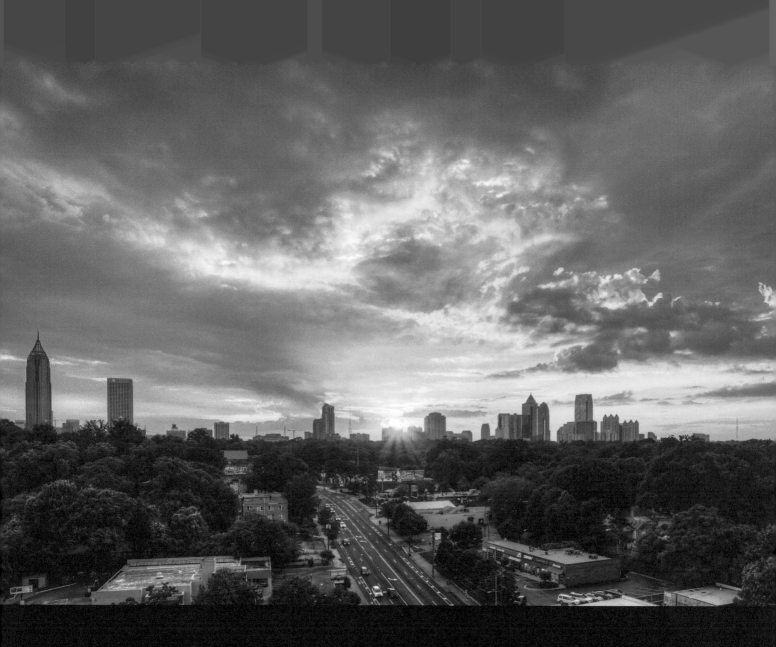

First there was Water: Ponce de Leon Avenue

It began in the 1860's with railroad workers and a natural spring with reported rejuvenating properties. Named for the fabled fountain sought by explorer Ponce de Leon, Atlantans flocked to this water source primarily from the west via Peachtree Street. A new road took form that centered around the businesses that sprang up along with the waters: delivery carts hauled bottles directly to Atlanta residents, while trolleys and eventually streetcars brought visitors to the springs and the Ponce de Leon Amusement Park from 1872 through 1924.

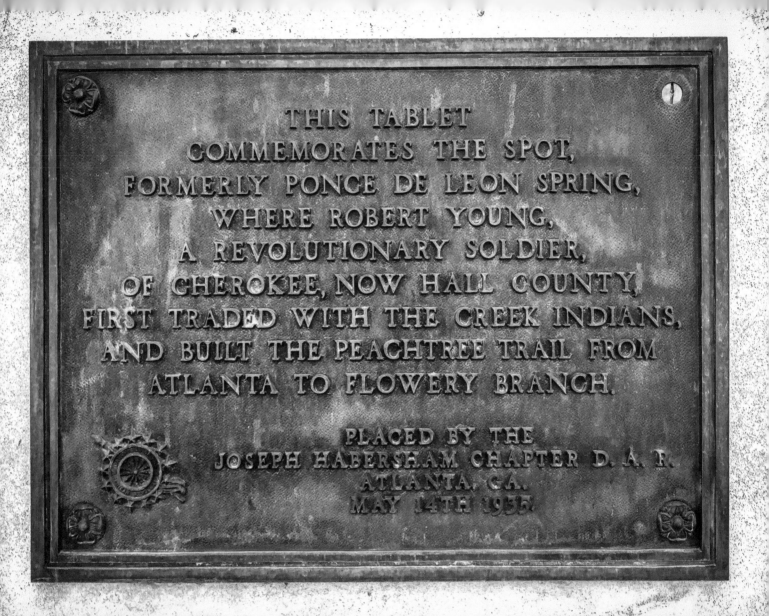

THIS TABLET
COMMEMORATES THE SPOT,
FORMERLY PONCE DE LEON SPRING,
WHERE ROBERT YOUNG,
A REVOLUTIONARY SOLDIER,
OF CHEROKEE, NOW HALL COUNTY,
FIRST TRADED WITH THE CREEK INDIANS,
AND BUILT THE PEACHTREE TRAIL FROM
ATLANTA TO FLOWERY BRANCH.

PLACED BY THE
JOSEPH HABERSHAM CHAPTER D. A. R.
ATLANTA, GA.
MAY 14TH 1935

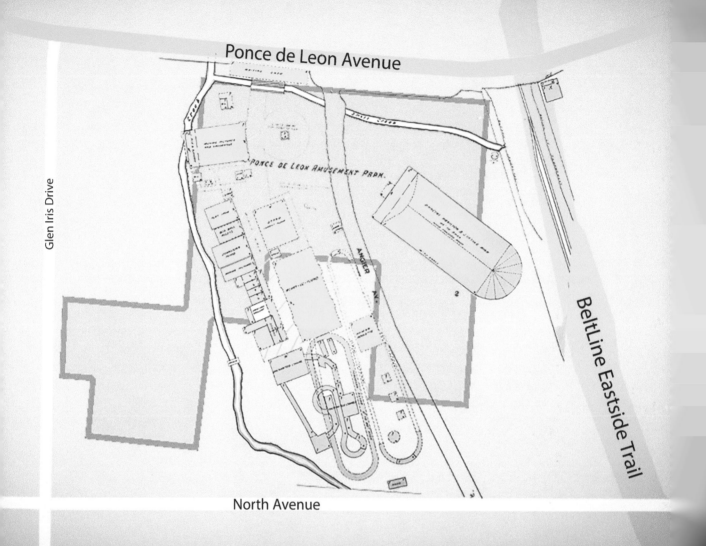

Ponce de Leon Avenue

Glen Iris Drive

BeltLine Eastside Trail

North Avenue

By 1911 the amusement park occupied much of the area from Ponce de Leon Avenue to what is now North Avenue, and between the future Glen Iris Drive and the Eastside BeltLine Trail. Of note is the northeast corner of the property near the start of the embankment and the edge of the coming Sears building, where the springs were presumably founded and eventually capped. Above: An approximation of the park structures to the building footprint, circa 1964. Park map sourced from the Historic Fourth Ward Park Conservancy: http://www.h4wpc.com

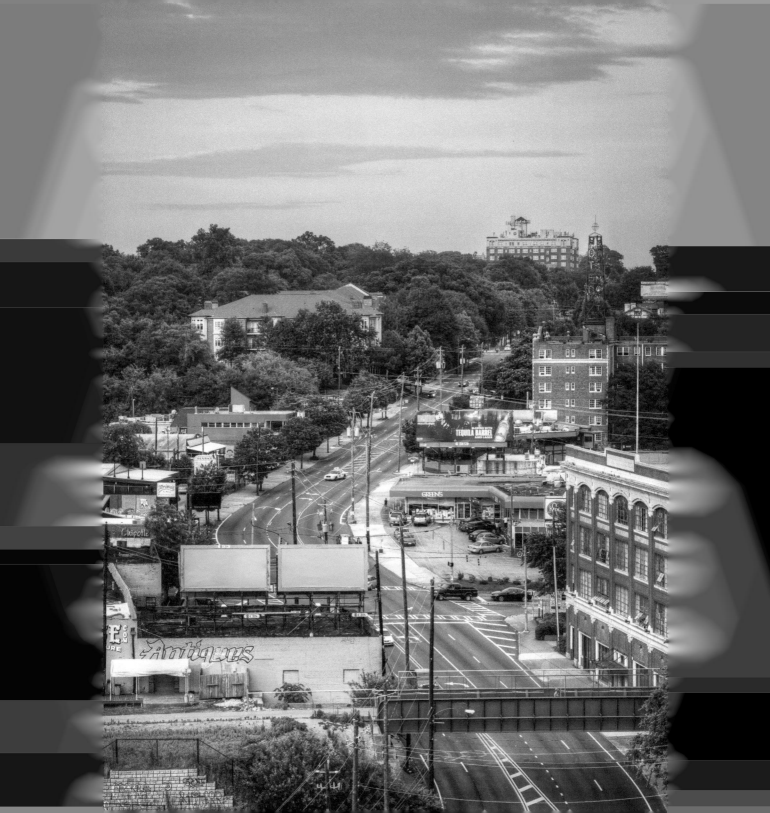

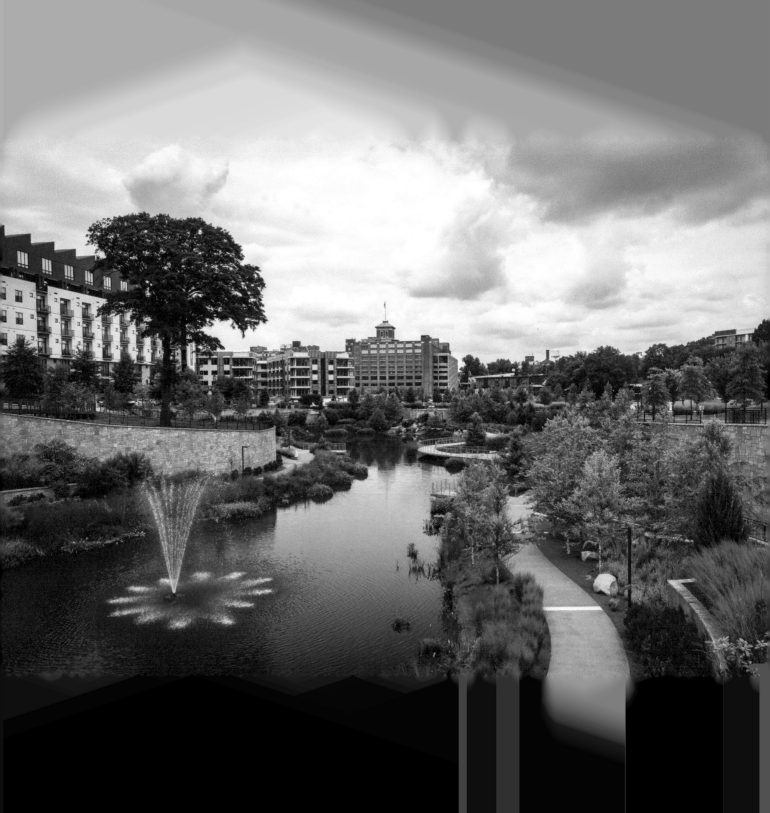

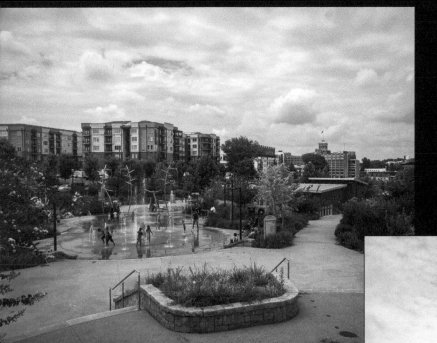

Historic Fourth Ward Park (H4WP) is located directly south across North Avenue. Part of the Atlanta BeltLine's urban parks, its presence is worth noting as H4WP serves both an aesthetic and utilitarian purpose crucial to revitalization of the Old Fourth Ward neighborhood. In early 2011 the stormwater retention pond (Clear Creek Basin) was completed and serves a vital role in managing runoff in an area formerly prone to flooding.

The addition of nearby residences, park amenities like the splash pad and skate park, and convenient access to the Atlanta BeltLine Eastside Trail would complement the "live-work-play" ideals of the forthcoming Ponce City Market.

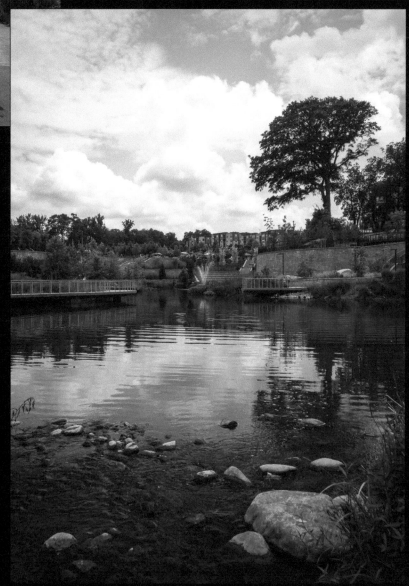

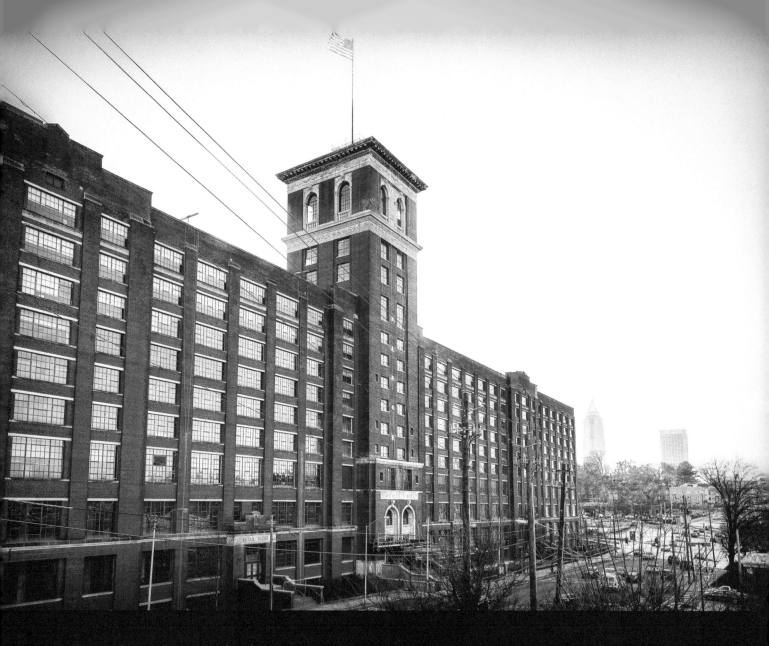

An Original Icon: Sears Roebuck & Company

The new Sears building was constructed and opened in 1926 on Ponce de Leon Avenue to serve as a retail storefront, office headquarters, warehouse, and catalog distribution center for the southeast. Multiple additions were made to the building over the decades due to growth, but eventually the catalog fulfillment operations ceased, followed by retail operations in 1979 and their offices in 1987, leaving the building empty and abandoned for over a decade. A wide range of equipment and tools were left where they were, frozen in time.

AUTO CONTROL
FAN S

FRESH AIR

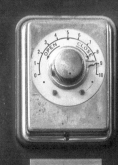

RETURN AIR

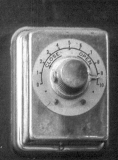

RELIEF AIR

SUMMER-WINTER

AIR CONDITIONING SYSTEM
SEARS ROEBUCK AND CO.
ATLANTA, GA.
M. G. HARBULA AND ASSOCIATES
CONSULTING AIR CONDITIONING ENGINEERS
WHEATON, ILL.

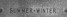

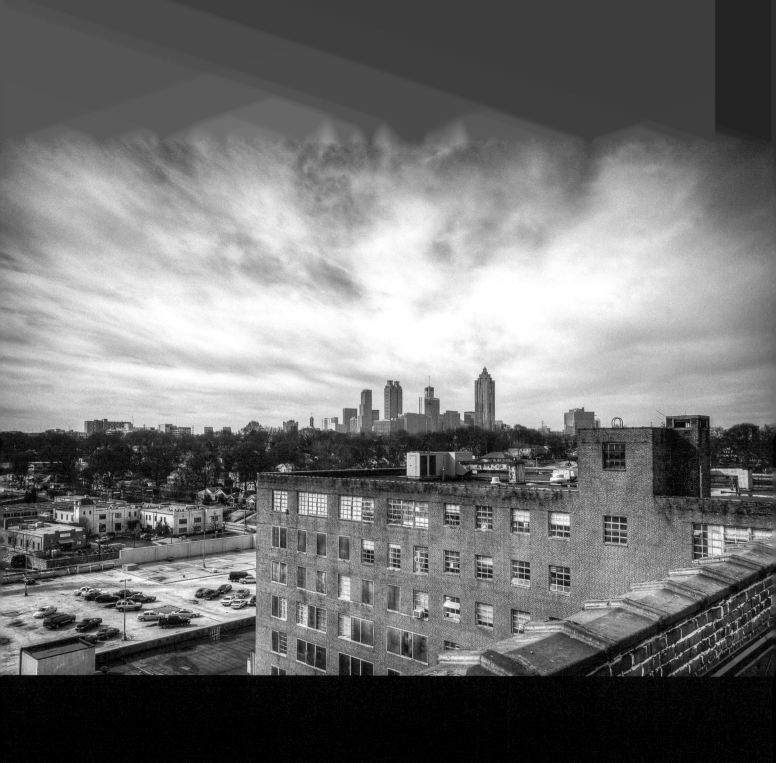

Looking southwest into Midtown Atlanta from behind the tower, ca 2008

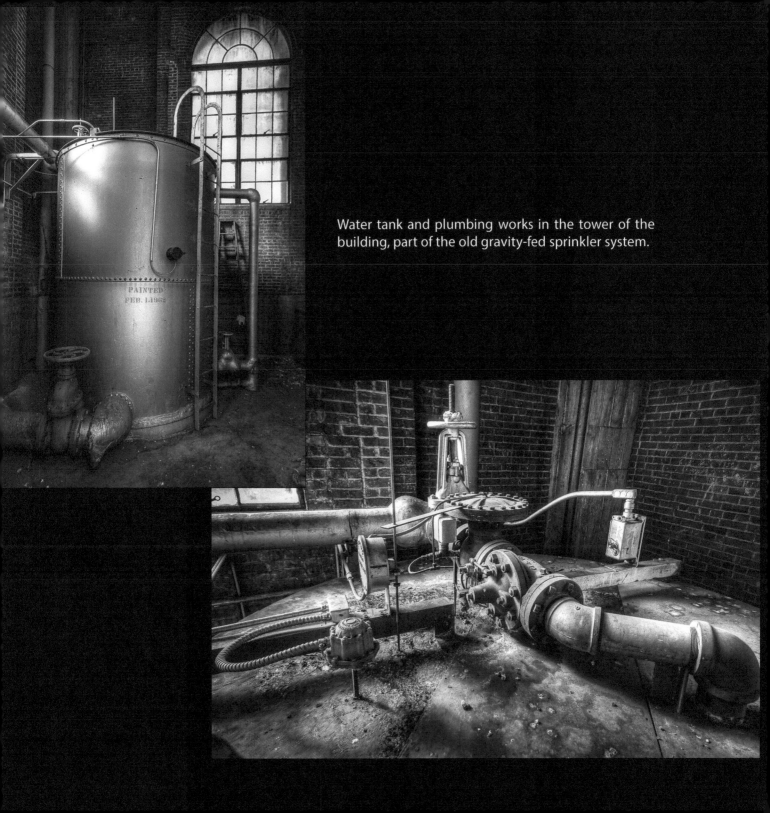

Water tank and plumbing works in the tower of the building, part of the old gravity-fed sprinkler system.

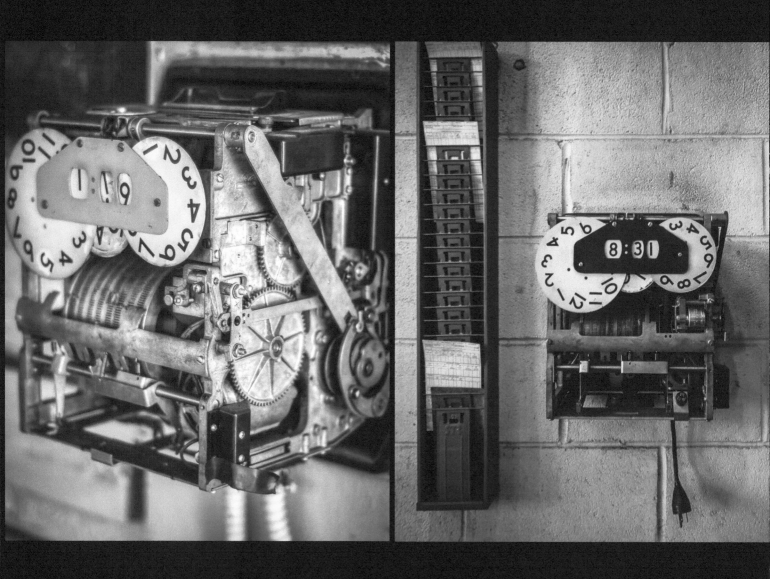

Time clocks and punch cards found throughout the buildings.

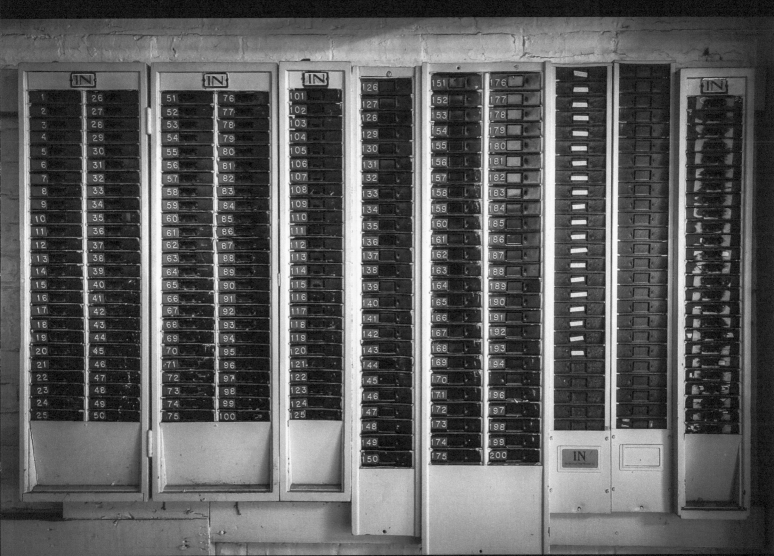

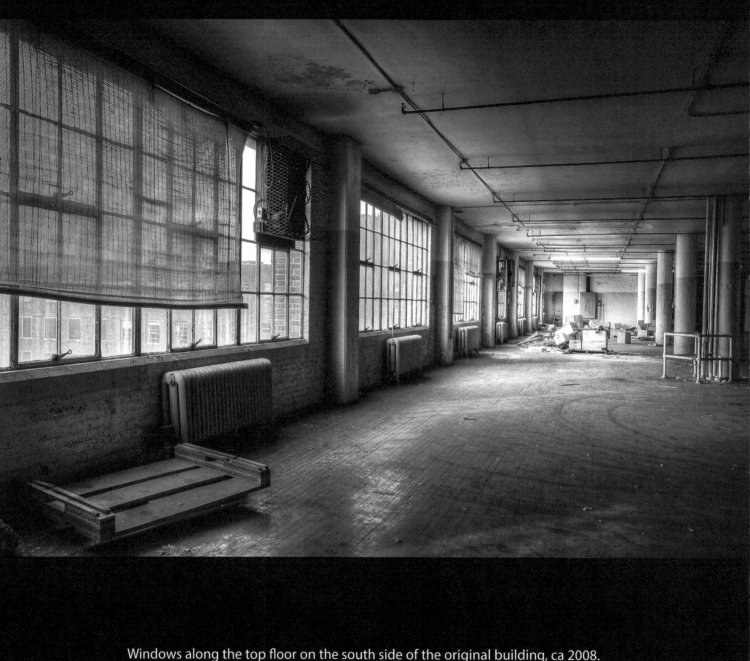

Windows along the top floor on the south side of the original building, ca 2008.

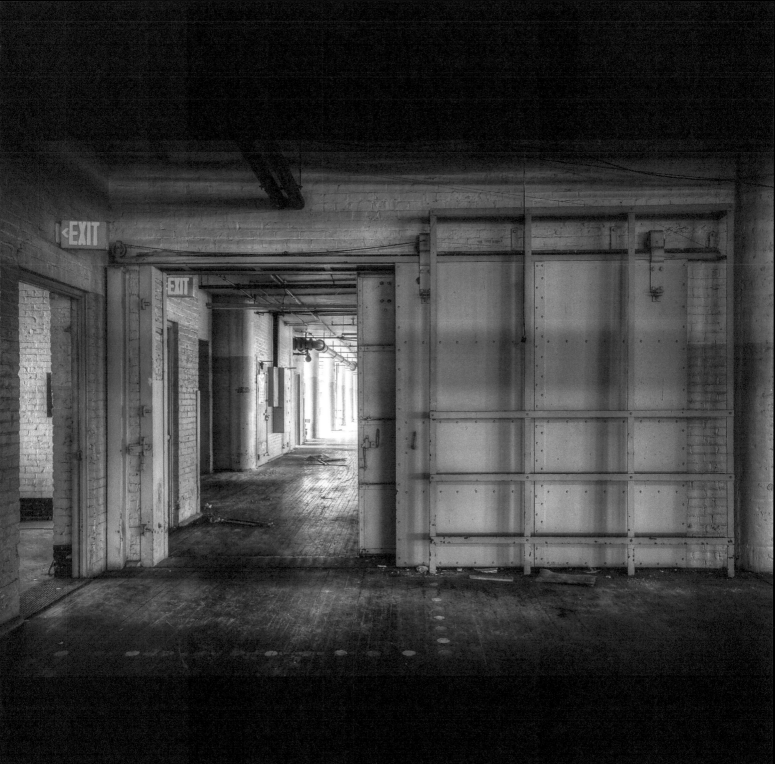

Oversized sliding metal doors separated huge expanses on several floors.

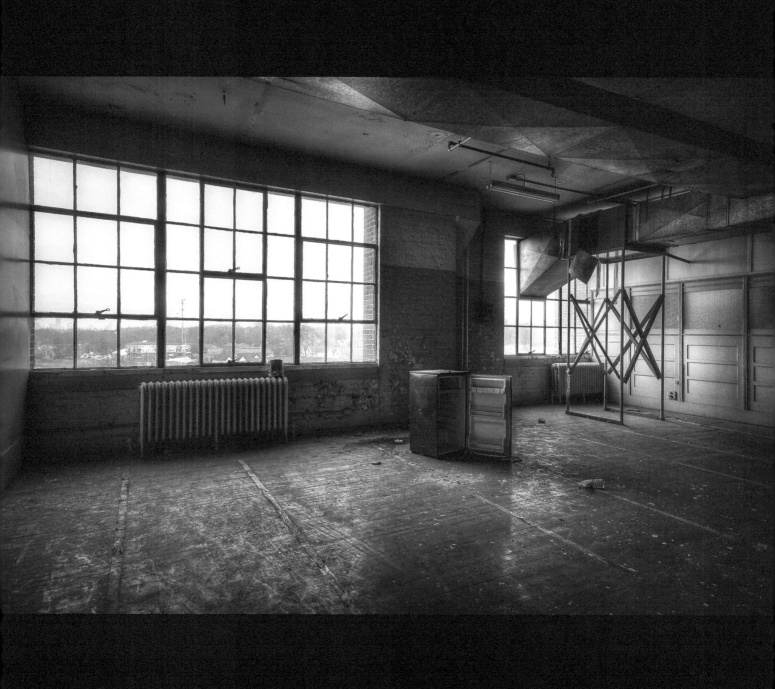

This window once overlooked Spiller Park, home to the Atlanta Crackers minor league baseball team, 1924-1932.

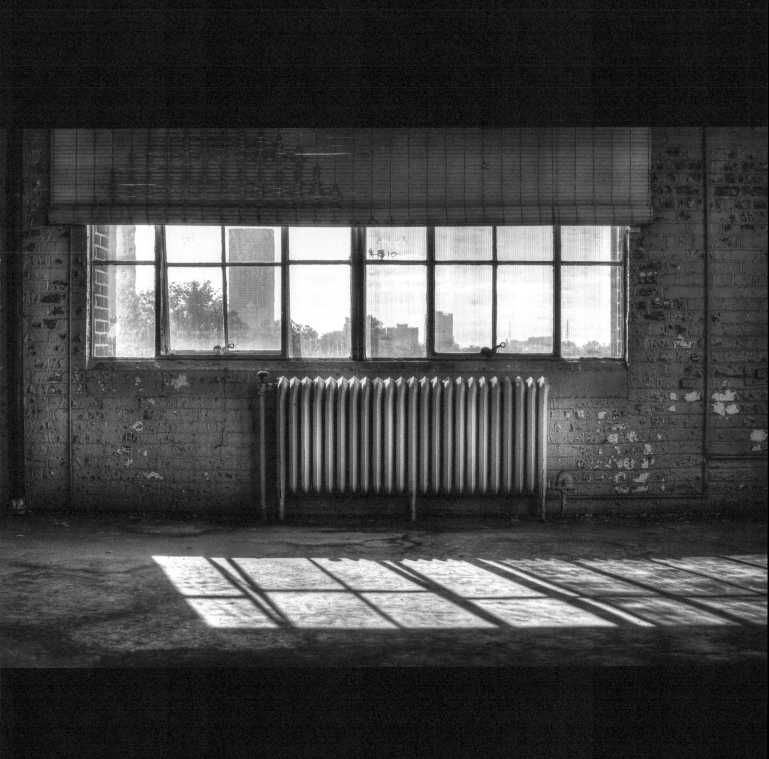

Steam for the radiators was provided by boilers in a "power plant" on the southeast corner of the property.

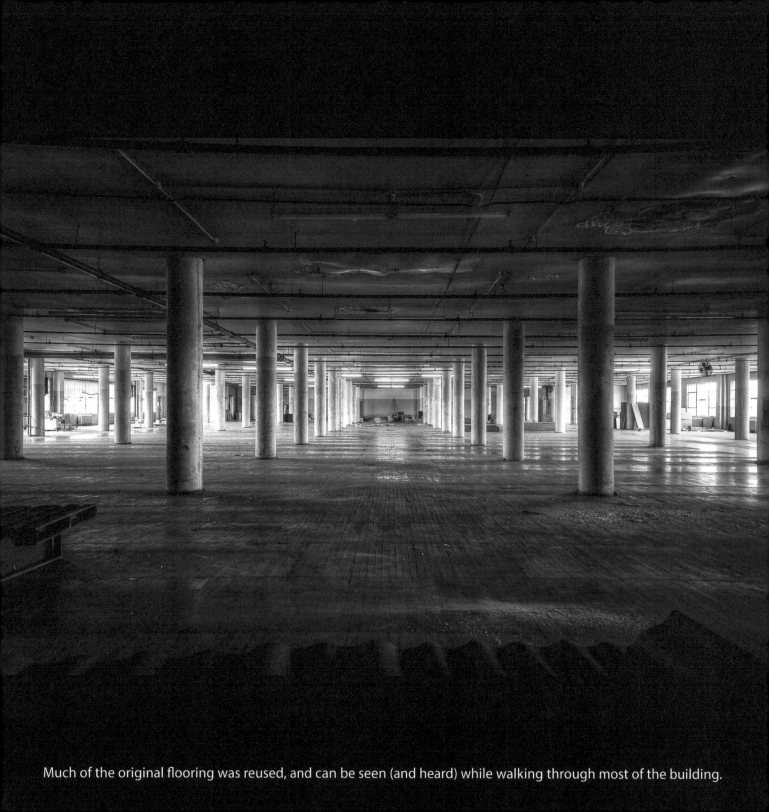

Much of the original flooring was reused, and can be seen (and heard) while walking through most of the building.

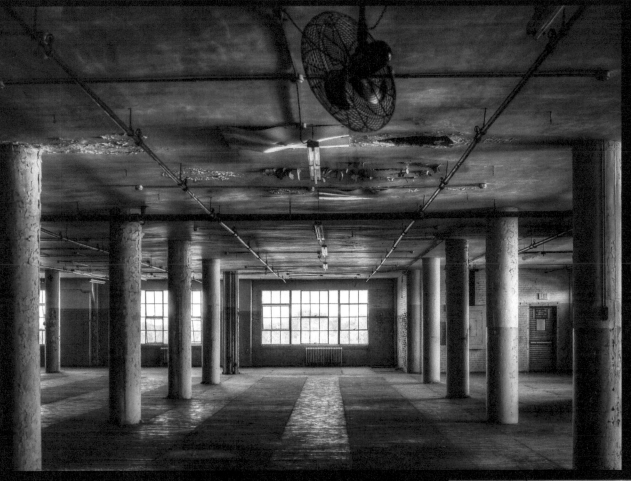

Artifacts such as these fans were carefully removed,
cataloged, and stored for display after renovations.

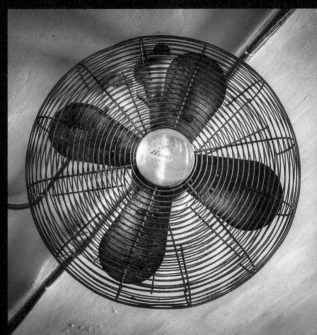

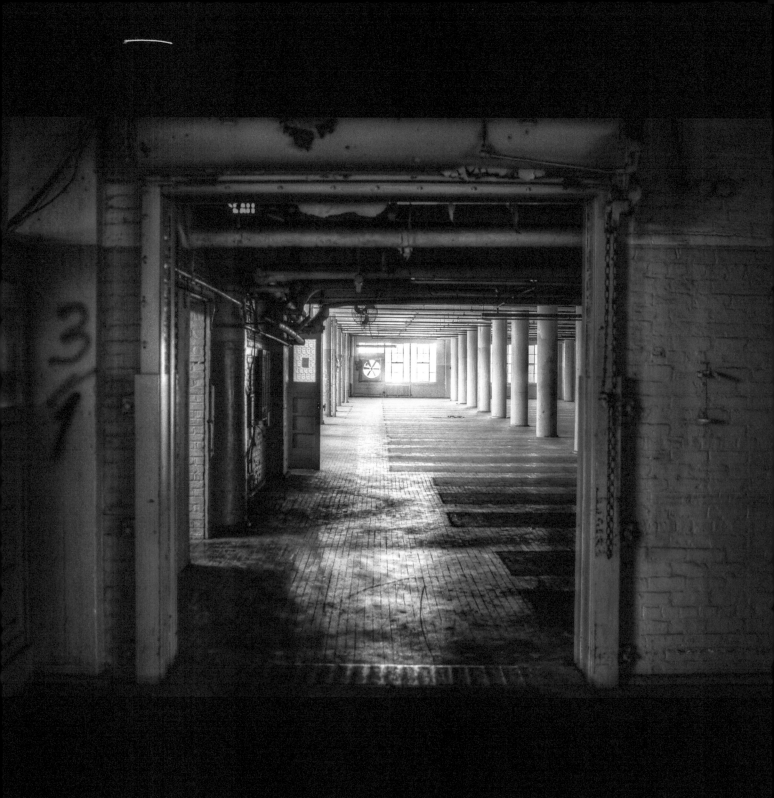

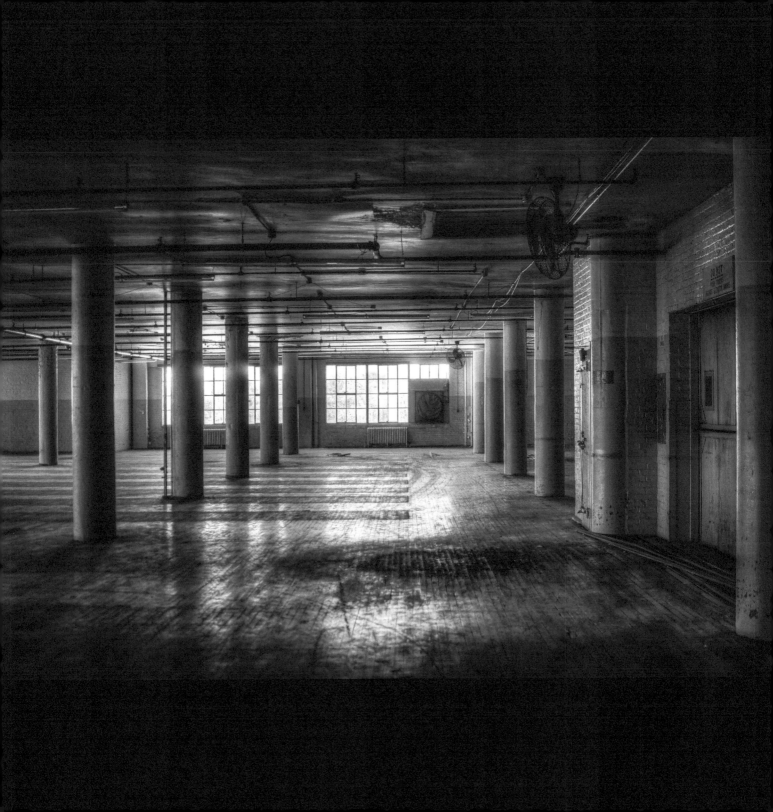

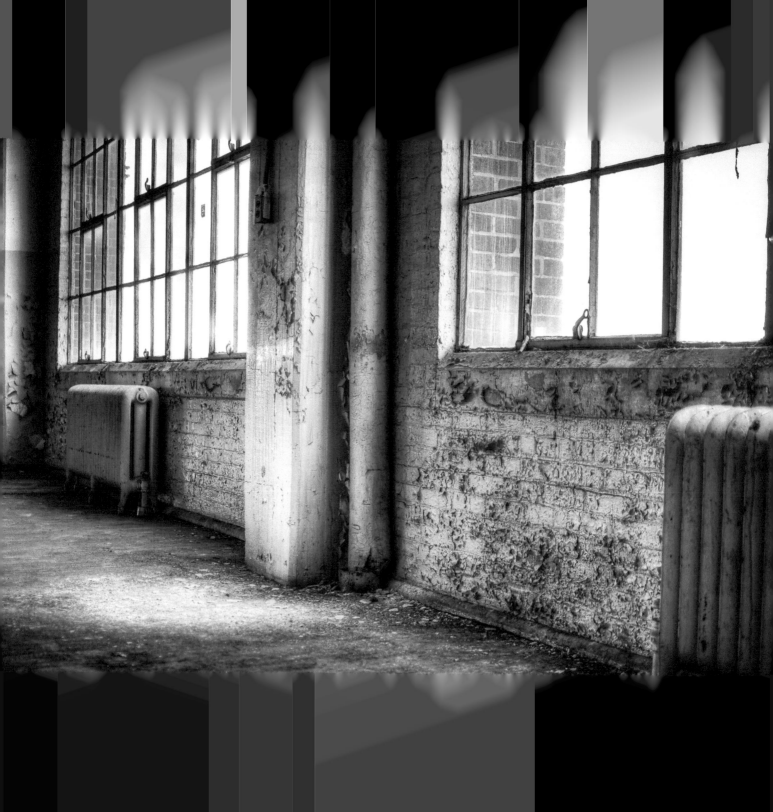

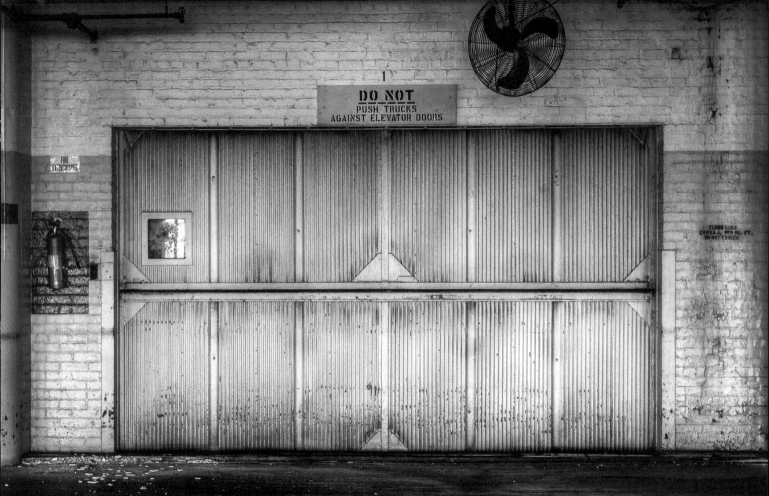

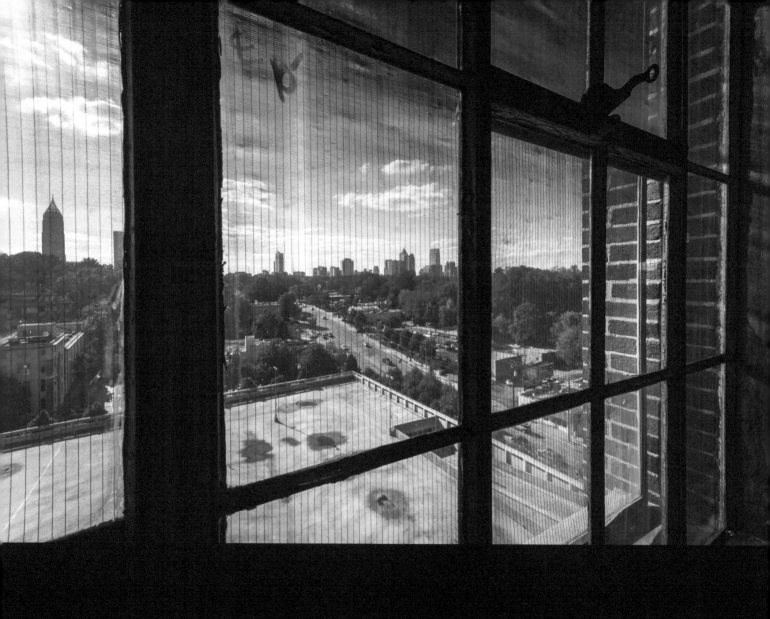

Every window in the building was refurbished with modern glass: 56,000 panes in all.

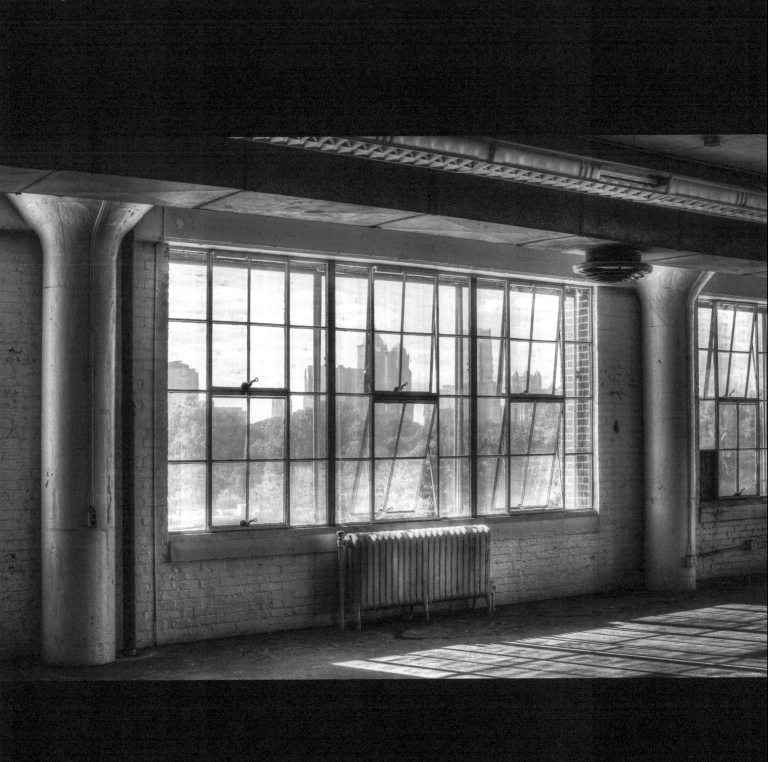

The original window frames were restored, allowing Ponce City Market to keep its historic façade.

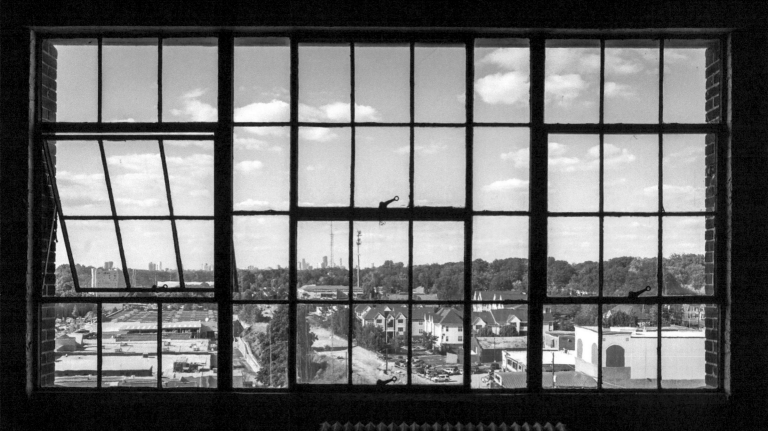

The Eastside Trail of the Atlanta BeltLine was still well under construction in 2011.

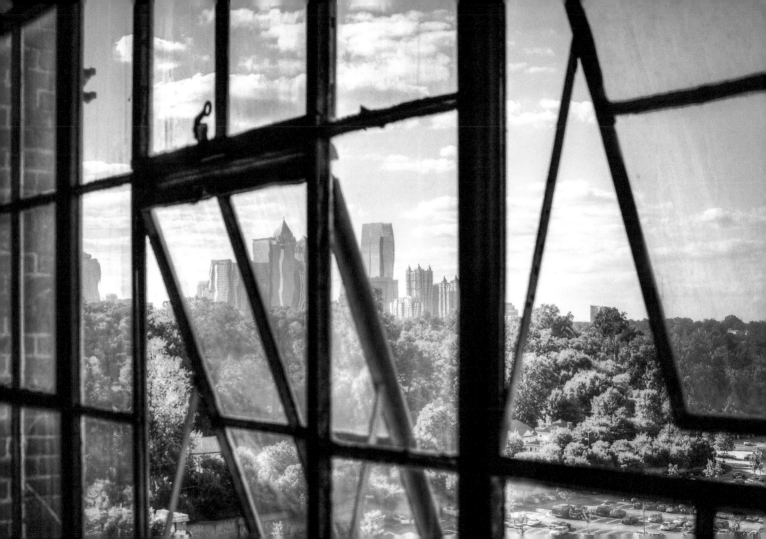

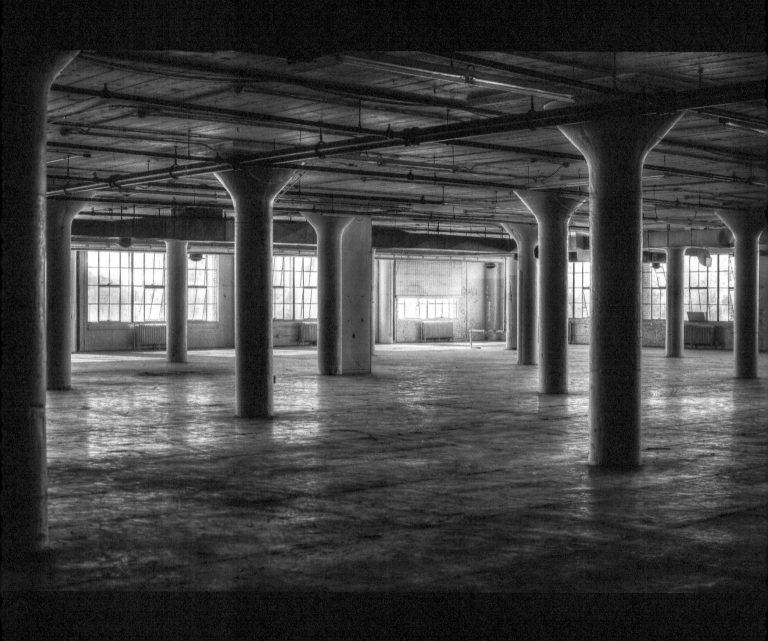

The mushroom columns typical for architecture of this era can be seen throughout the building.

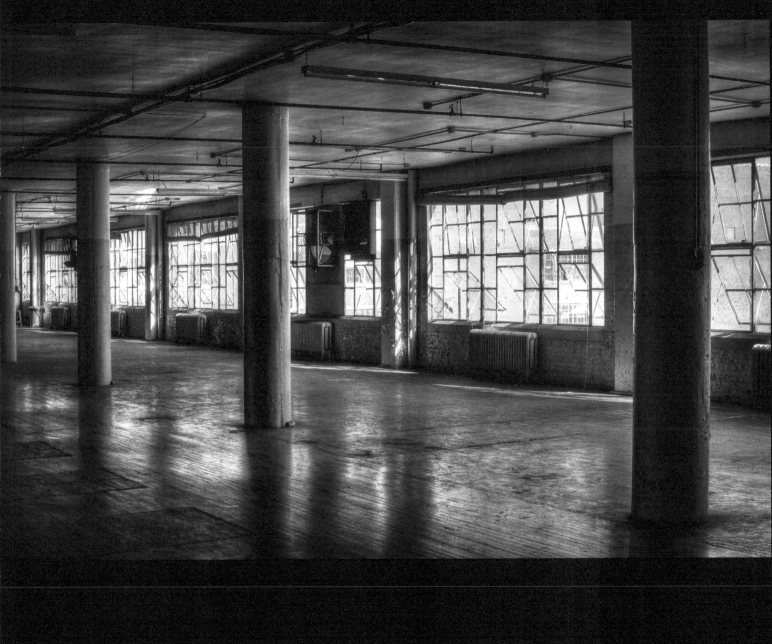

In some areas, a false ceiling masked the tops of the columns.

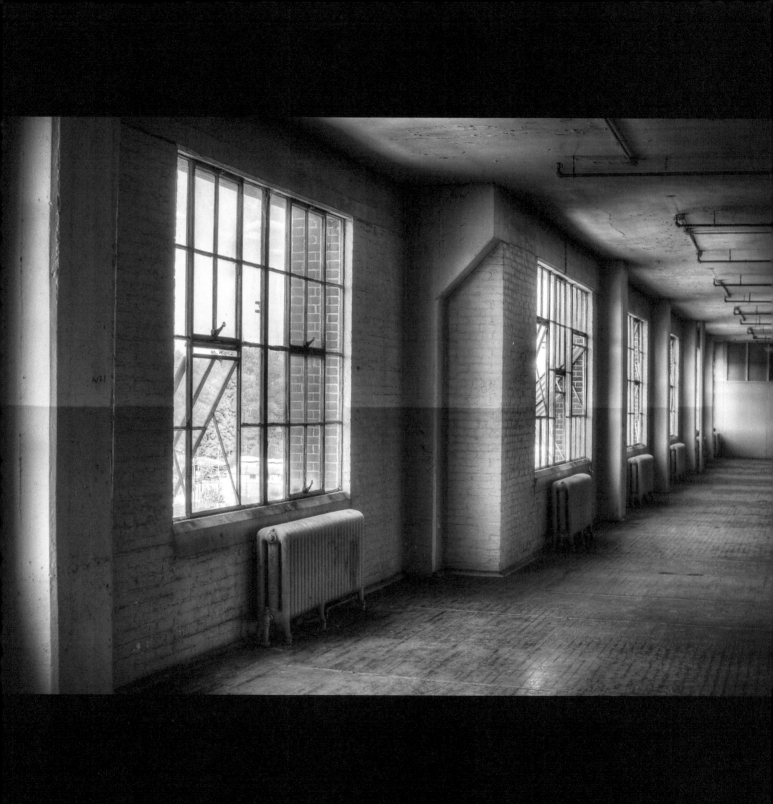

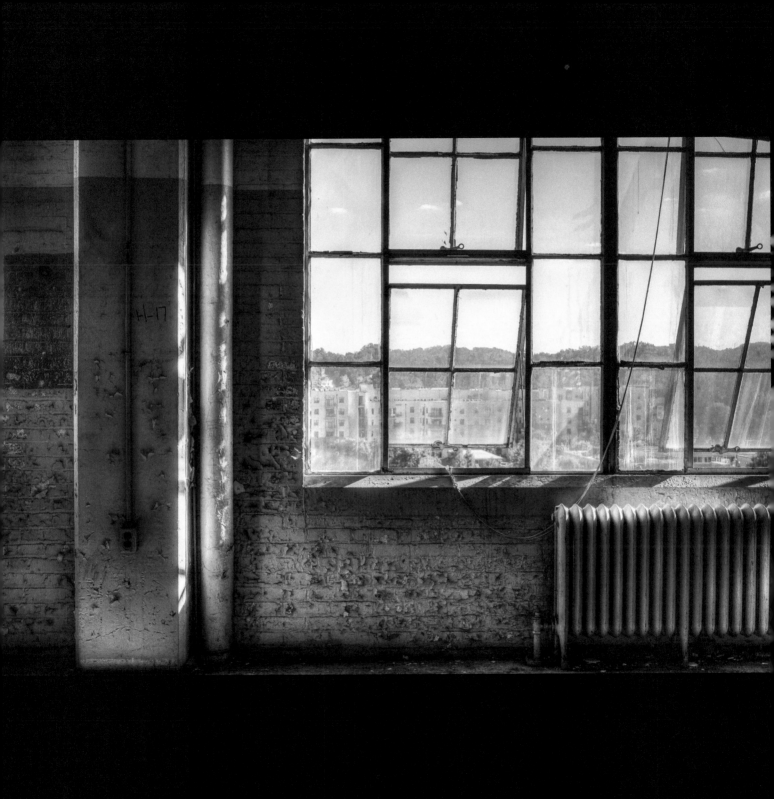

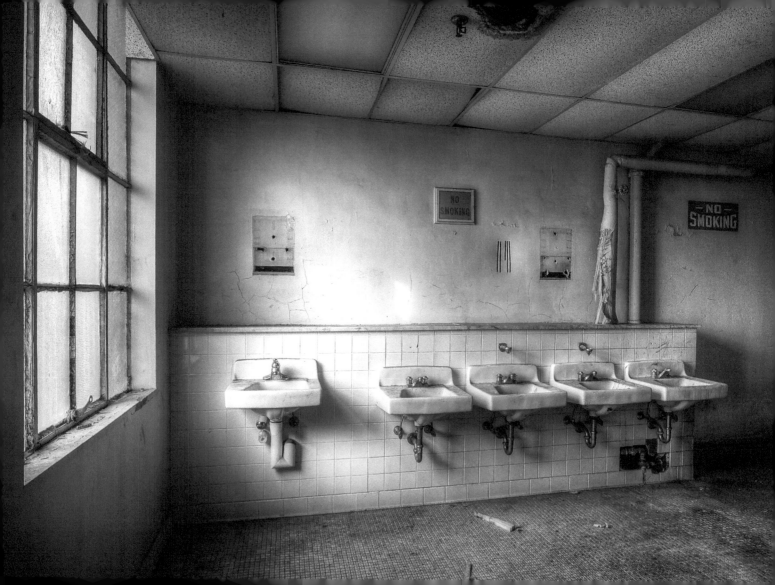

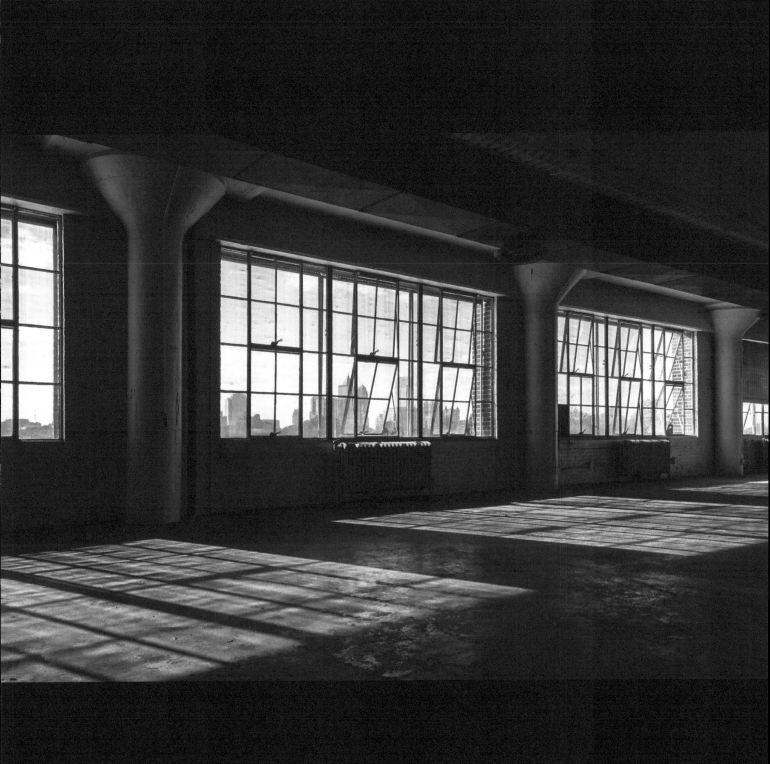

The original architect installed all windows in sets of three's.

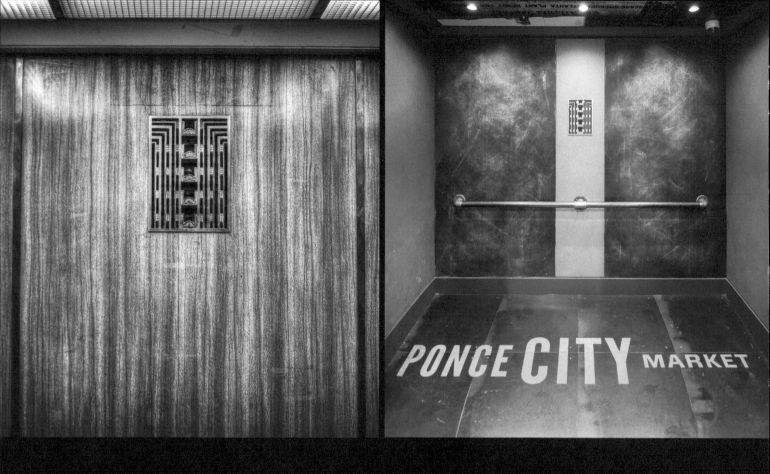

Gone is the wood paneling, though some art deco details were preserved within the passenger elevators below the tower. Each passenger elevator in the building contains a unique design element that reflects a piece of history from the days of Sears Roebuck & Co.

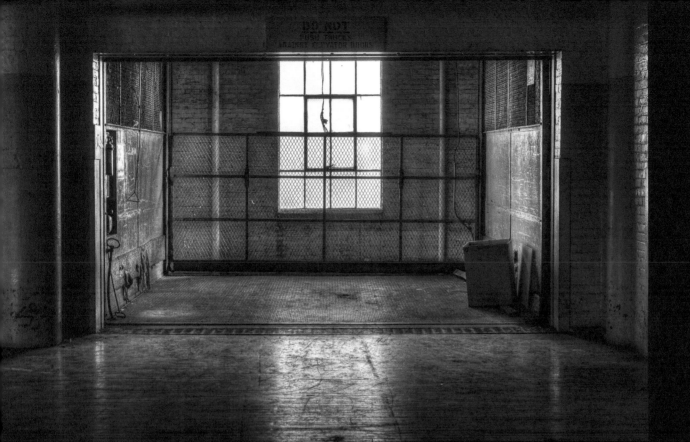

The freight elevators served an integral purpose for moving merchandise between floors of the former Sears building. Seen here, the west elevator (on the Glen Iris side) is still present, but now permanently fixed into place as the 1st floor entrance from the Marketplace into the Central Food Hall. The controls remain mostly untouched as a piece of history preserved for all to see.

On the east side, the original elevator has been replaced with a modern model to deliver patrons to Skyline Park on the roof. Pieces of the original elevator, including the controls and large red side panels, can still be seen integrated into the updated equipment.

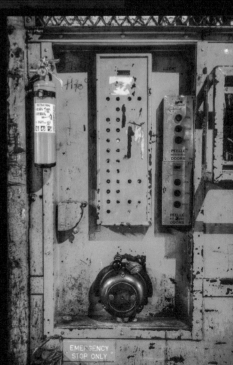

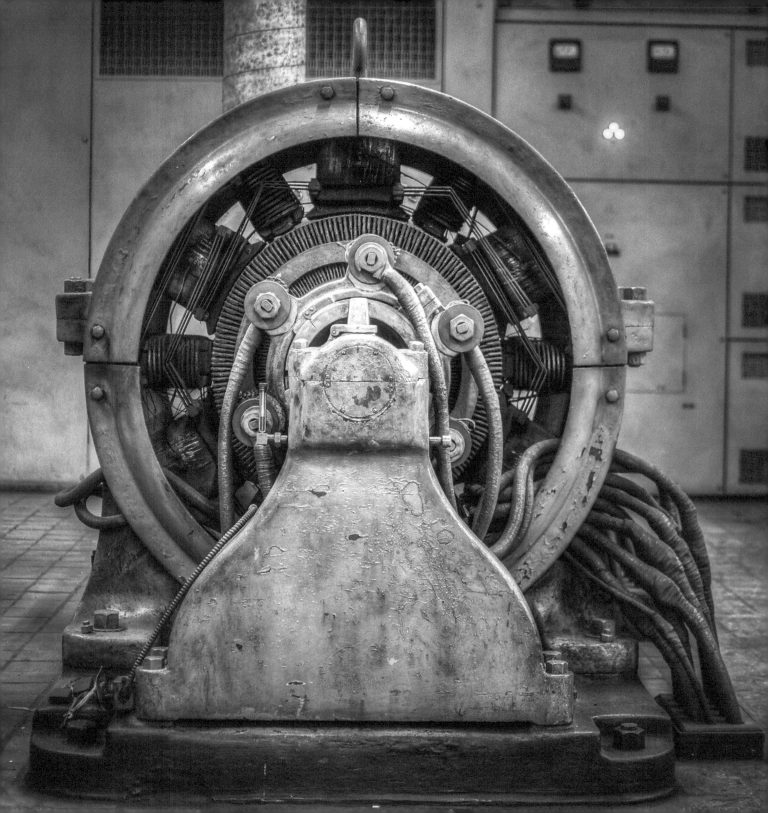

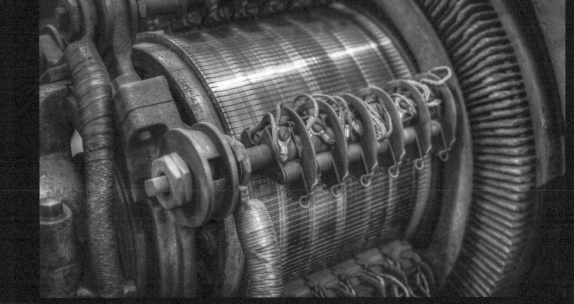

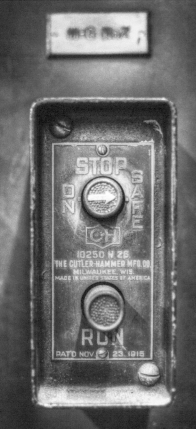

An incredible array of knife switches, breakers, generators, and transformers once filled a room on the first floor and provided power to every corner of the building.

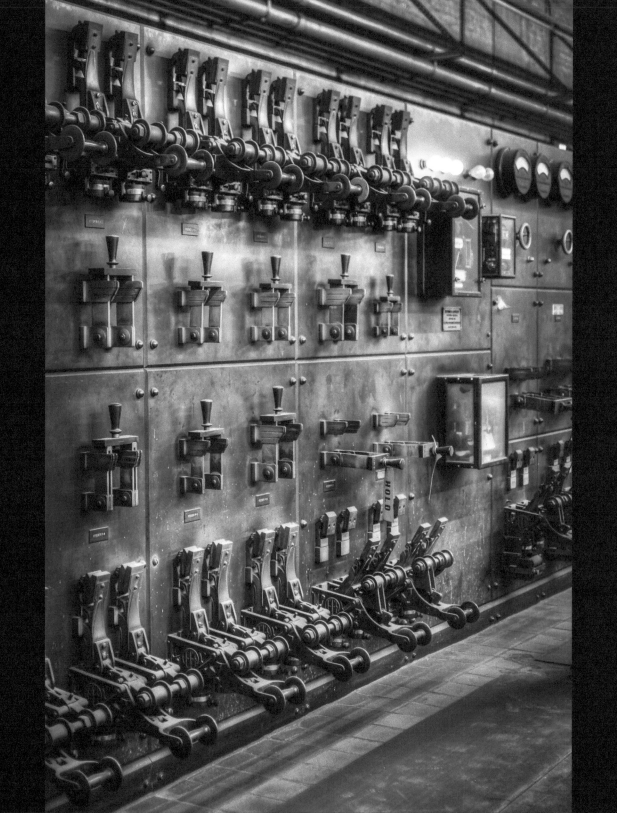

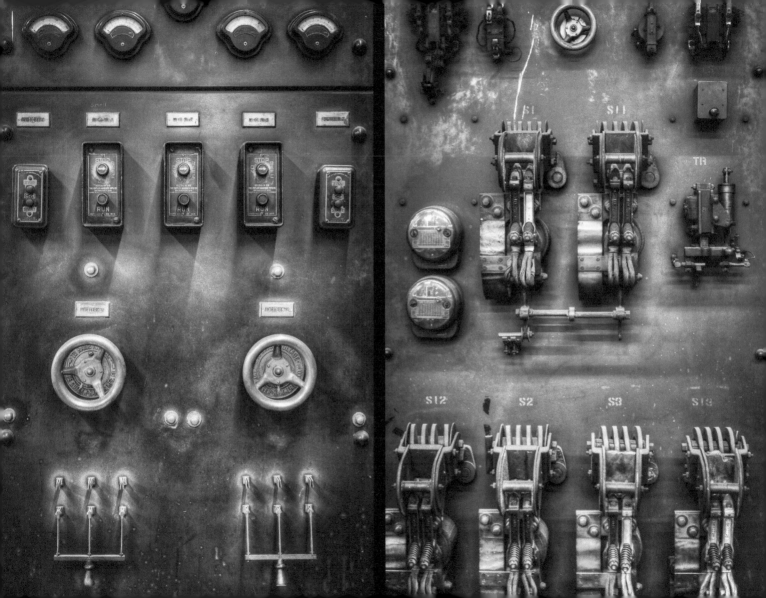

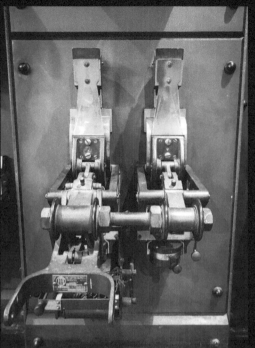
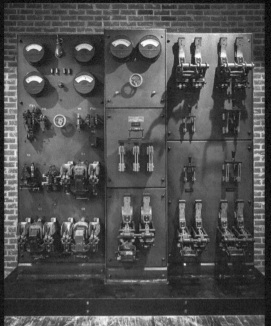
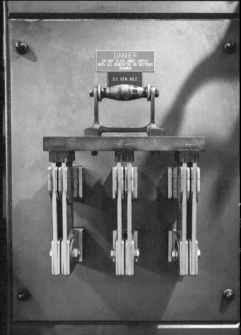
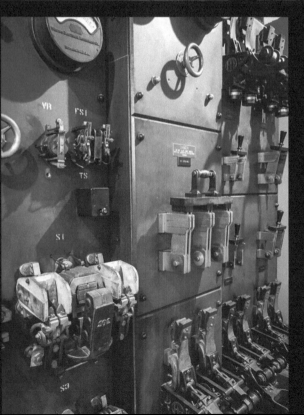

The same control panels, complete with many of their original parts, are now just artifacts on display in the lower level of the Central Food Hall.

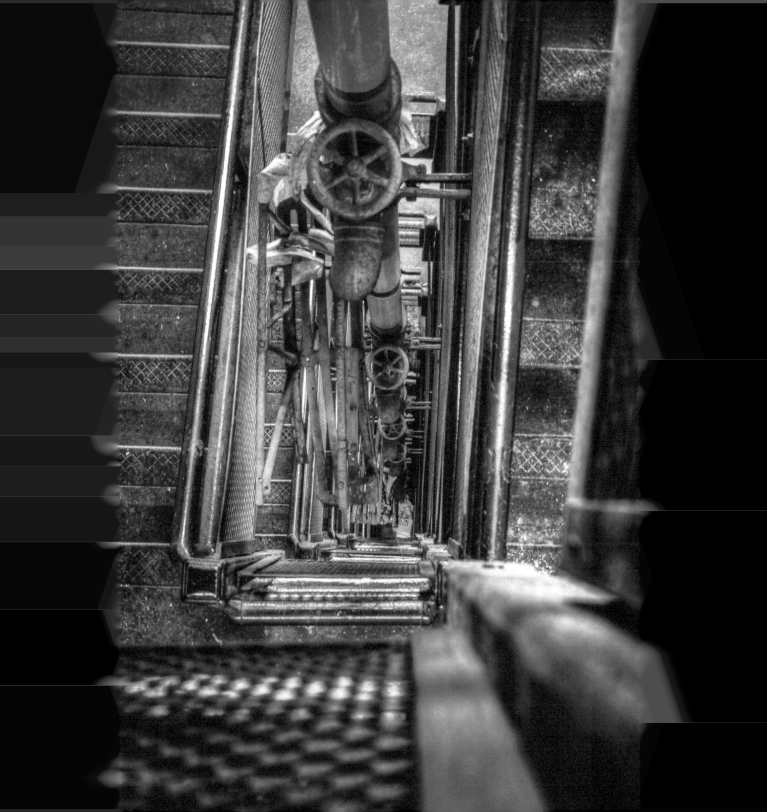

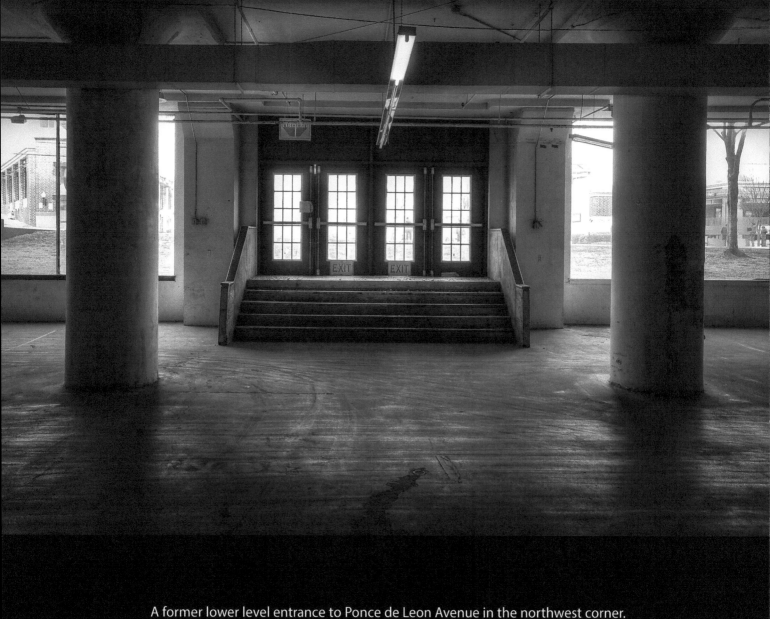

A former lower level entrance to Ponce de Leon Avenue in the northwest corner.

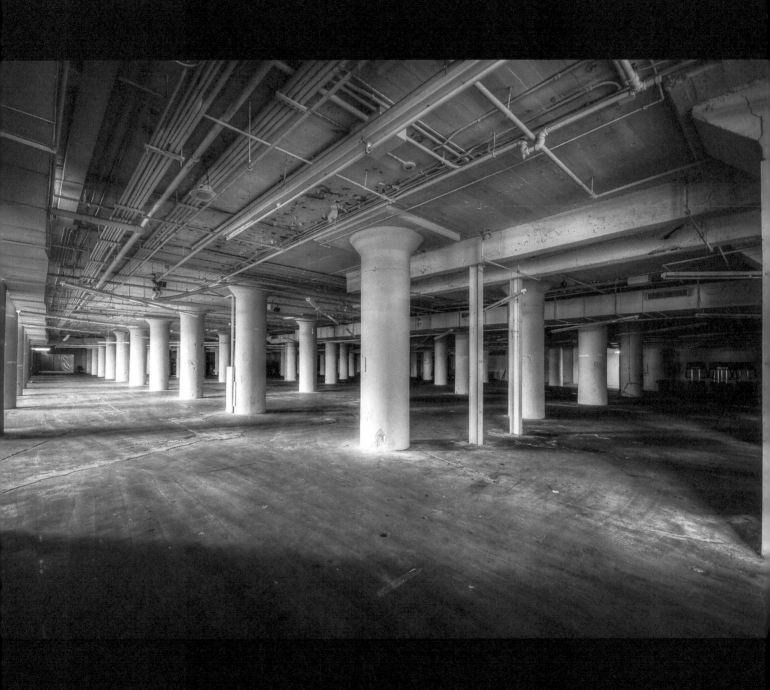

View opposite from Ponce de Leon Avenue lower entrance, now part of the lower level of parking.

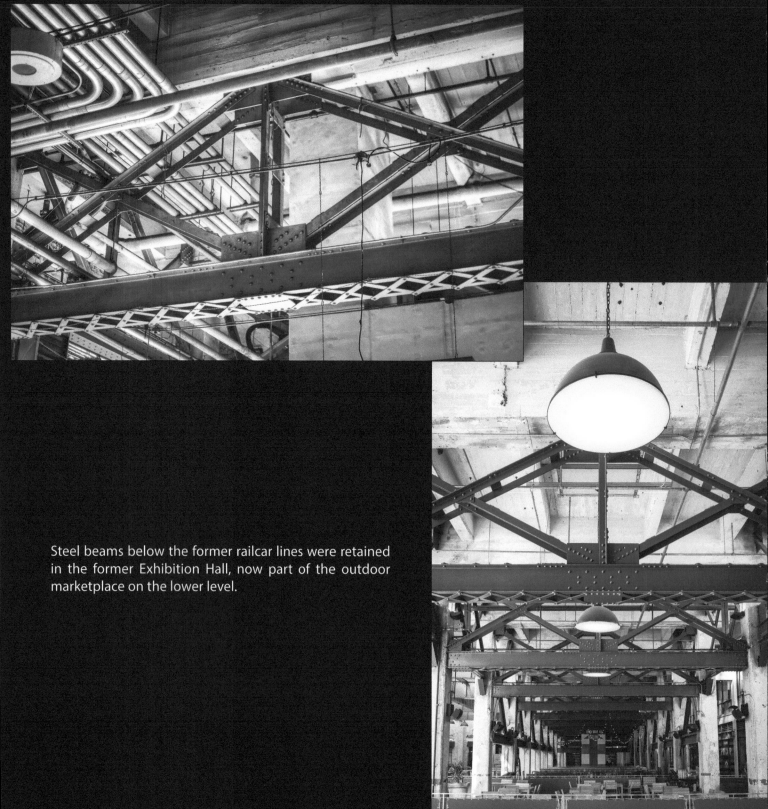

Steel beams below the former railcar lines were retained in the former Exhibition Hall, now part of the outdoor marketplace on the lower level.

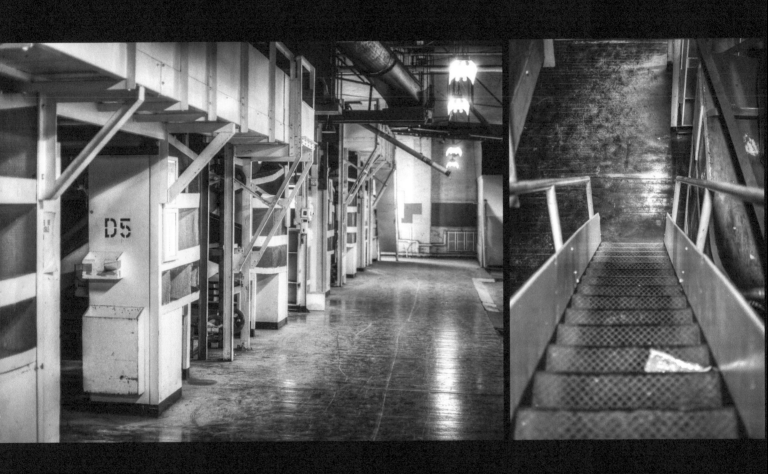

Multi-level sorting stations and chutes on the lower floor of the original building.

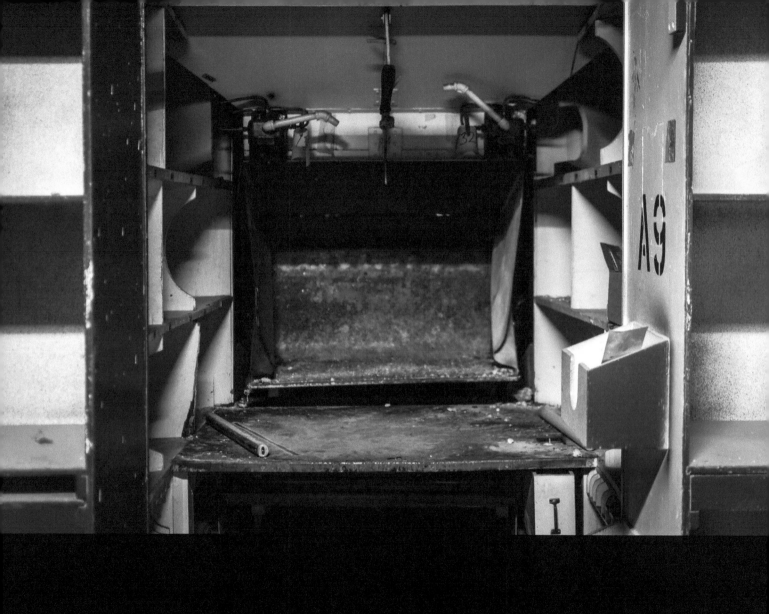

A sorting and wrapping cubicle used by Sears catalog fulfillment employees

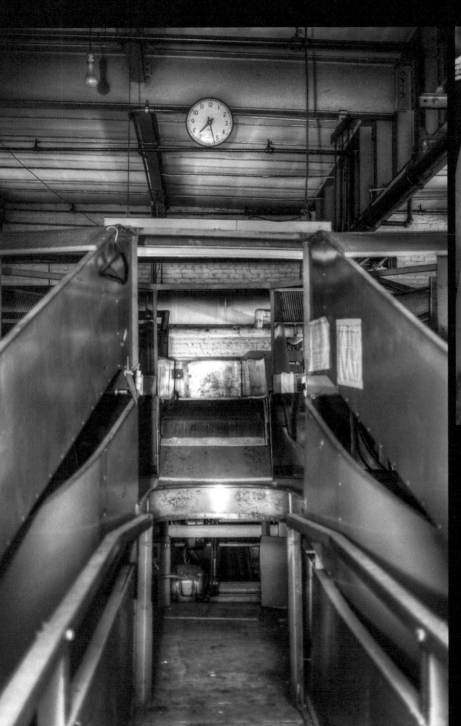
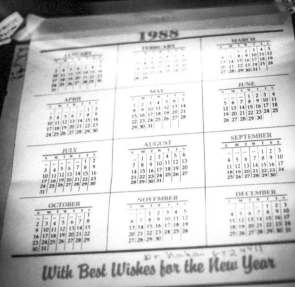

Sorting station with Sears Atlanta Employees Federal Credit Union calendar from 1988.

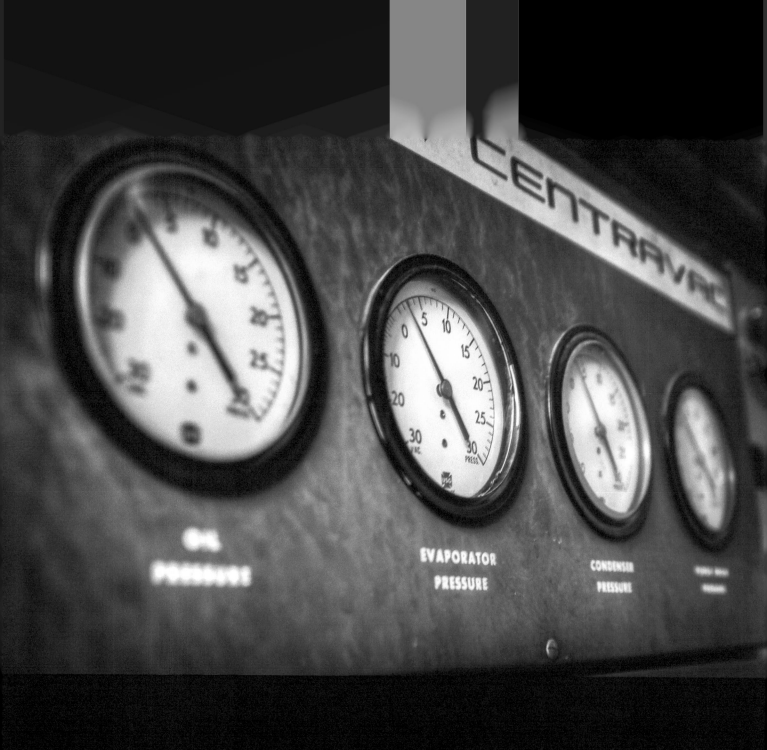

OIL PRESSURE

EVAPORATOR PRESSURE

CONDENSER PRESSURE

CENTRAVAC

Right: A view from the power plant (now gone) looking back toward the southeast corner of the building.

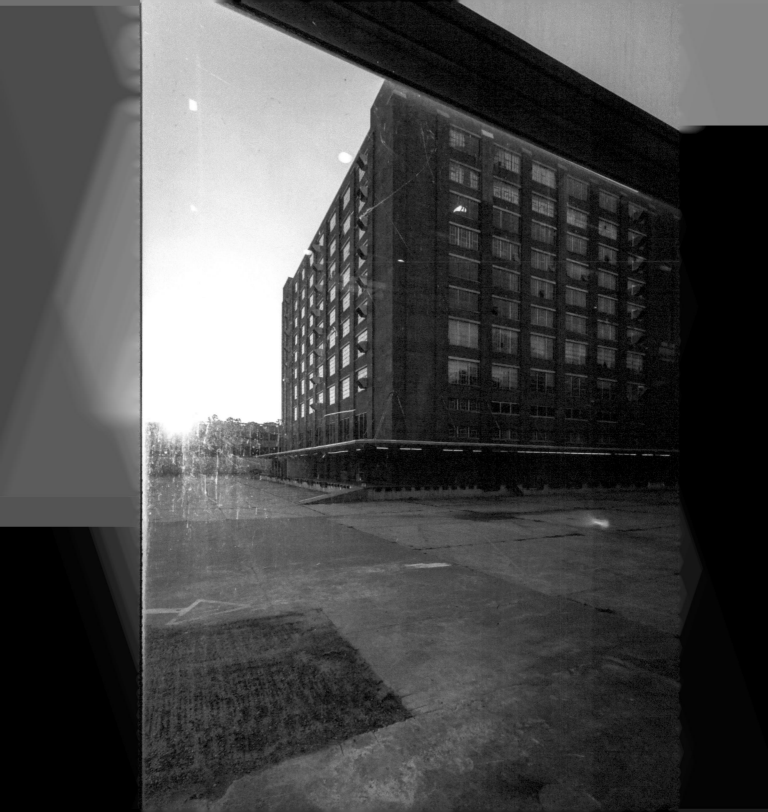

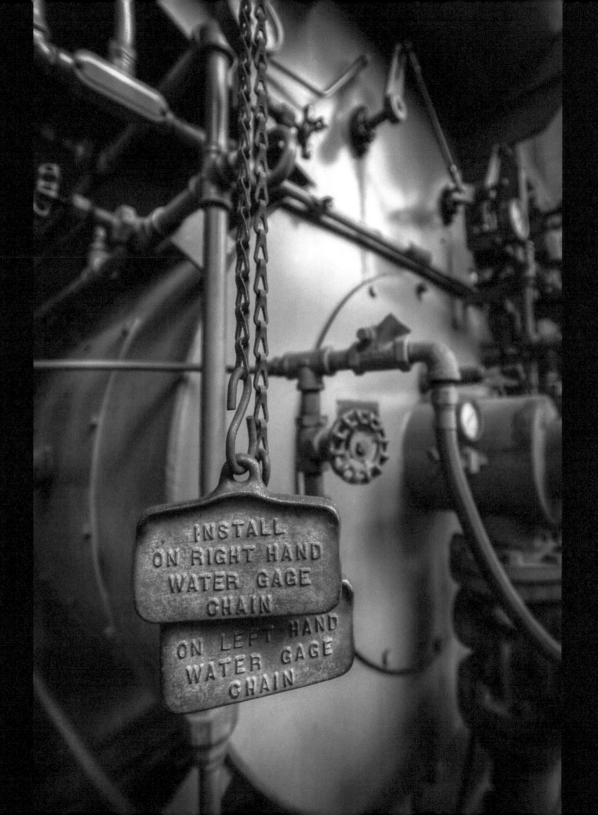

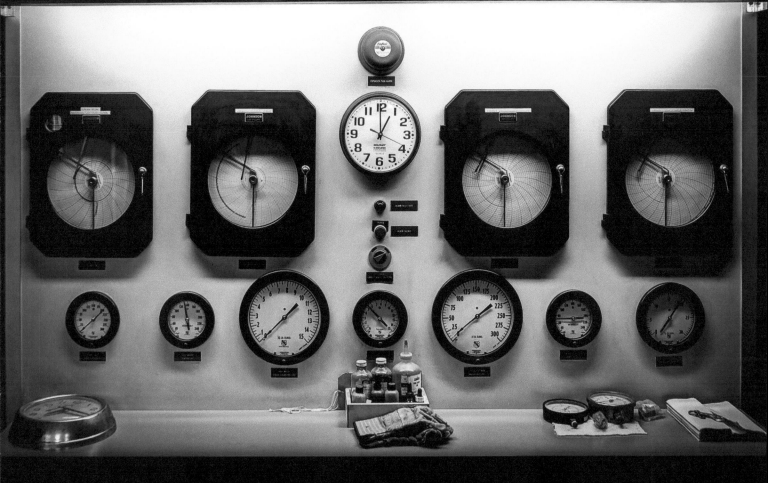

Pressure and temperature gauges above a meticulously organized condiment station for workers.

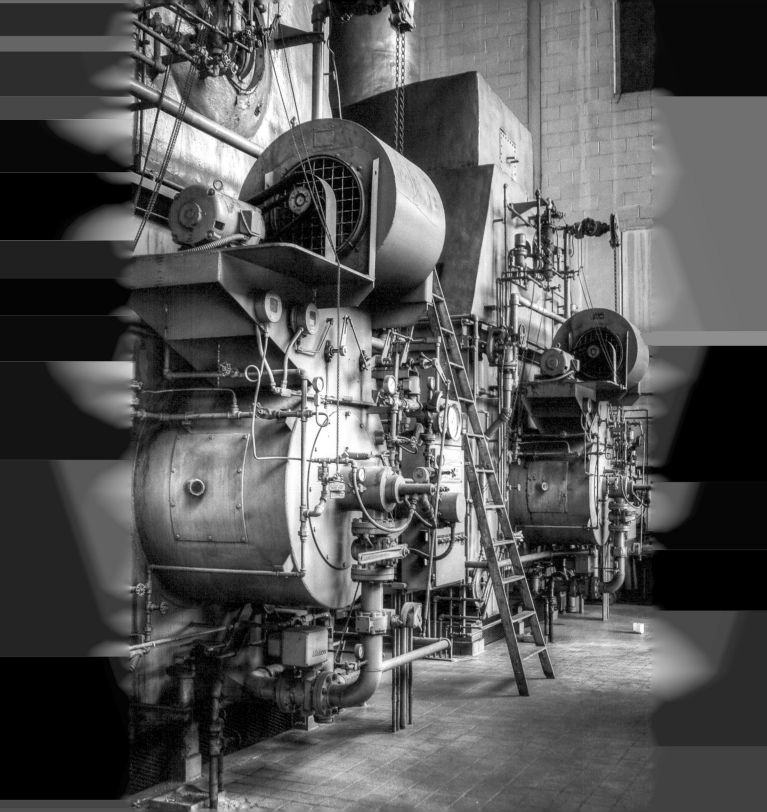

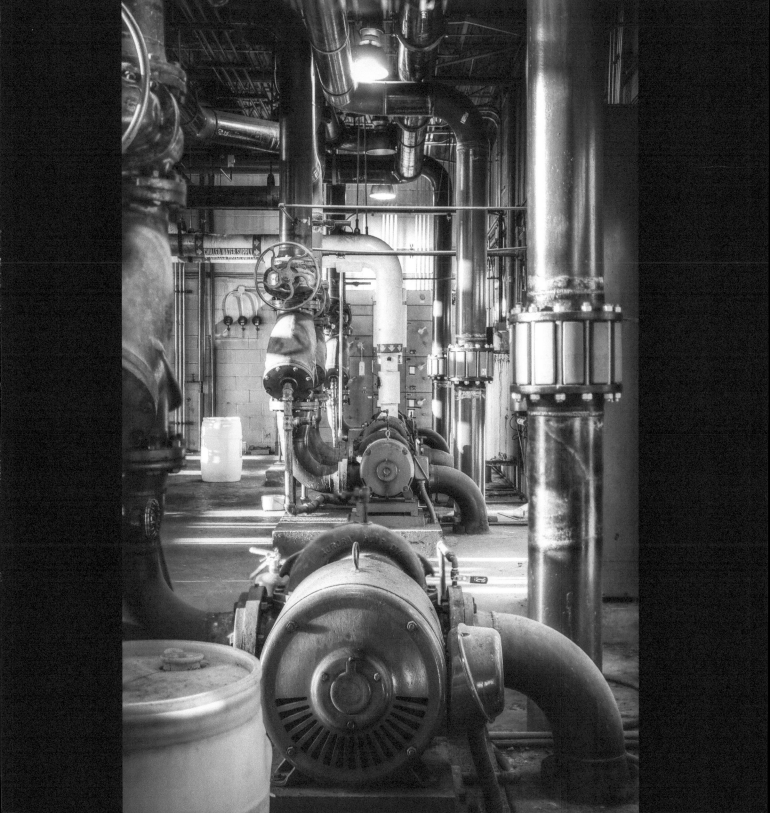

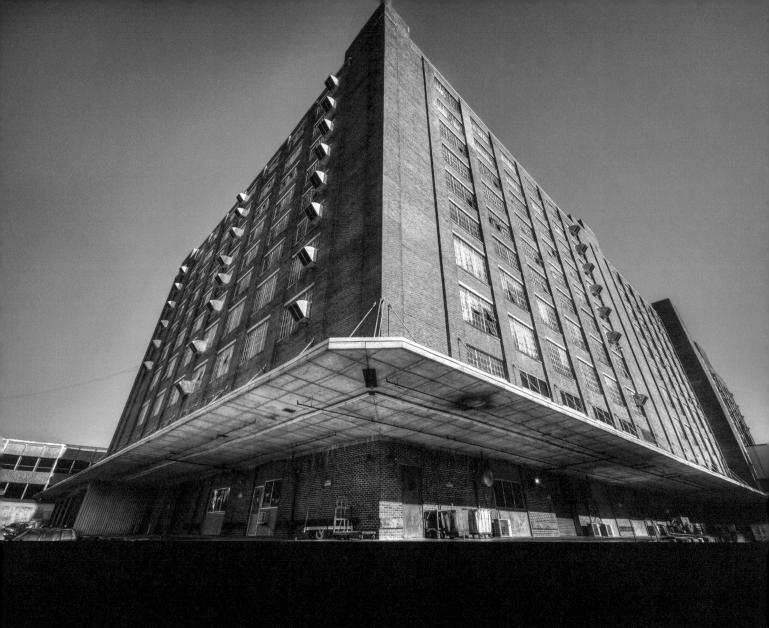

Looking up at the SE corner of the building, now converted into the lower level parking from North Avenue

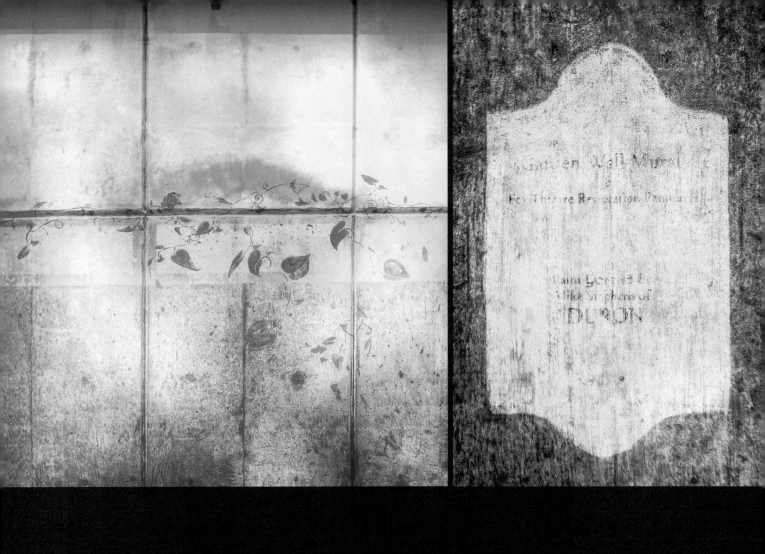

Part of the "Garden Wall Mural" once part of the North Ave. parking deck, now home to external retail shops

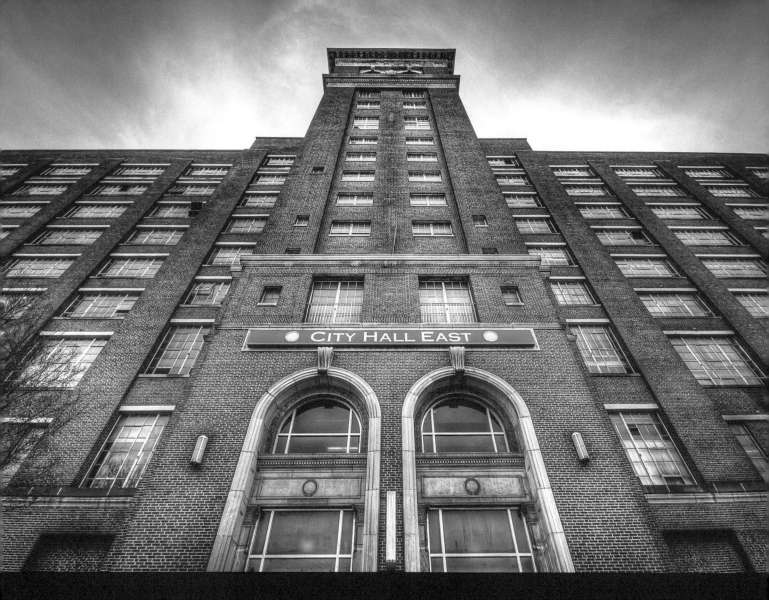

Changing Hands: City Hall East

The city of Atlanta purchased the property from Sears in 1991 for approximately $12 million. Space was utilized for public safety services including 911 dispatch and operations, and as a central office for the Atlanta police and fire departments. By 2010 the city had sold the property to private investors intending to renovate the space for a mixed commercial and residential project. As part of their departure from the building a massive "yard sale" event

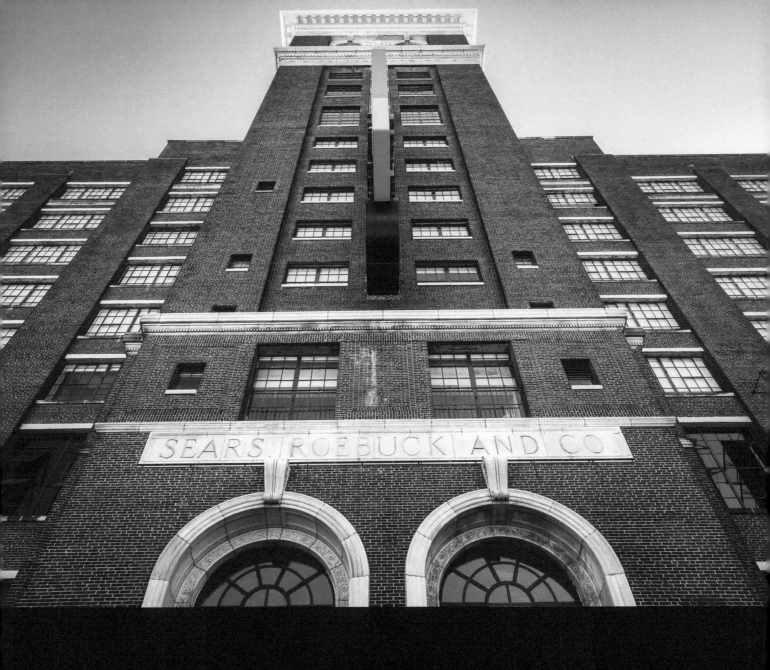

Removal of the City Hall East sign revealed the original "Sears Roebuck and Co" engravings.

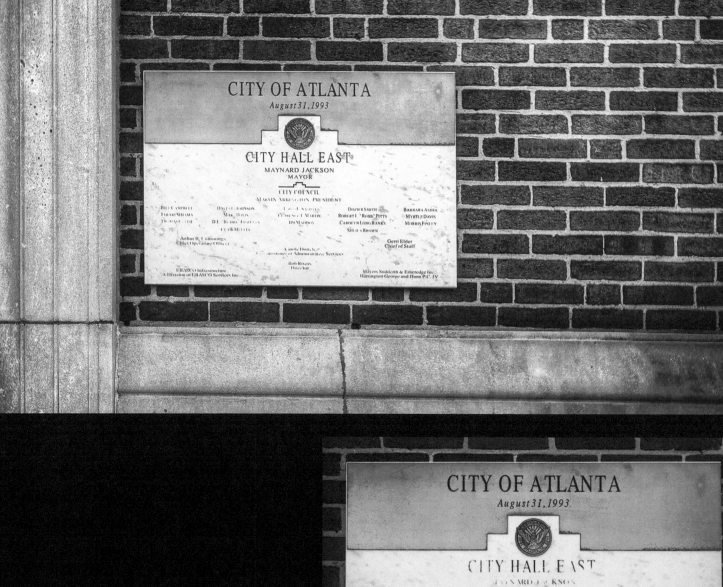

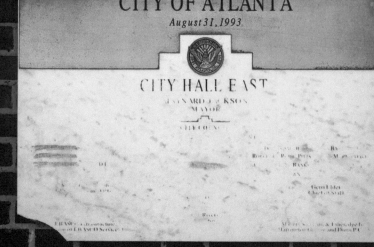

City Hall East dedication plaques, ca 2008, 2015

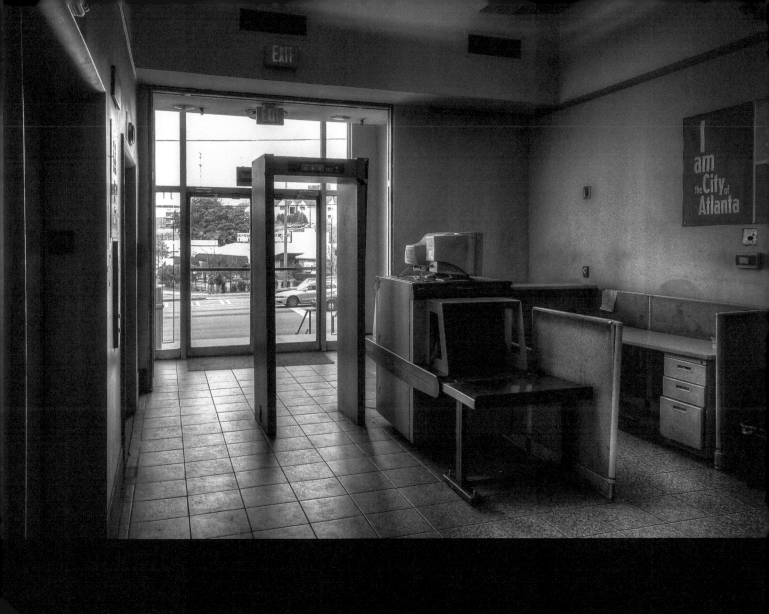

...urity checkpoint and metal detectors used by the Atlanta Police Department, now an entry to the Central Food Hall.

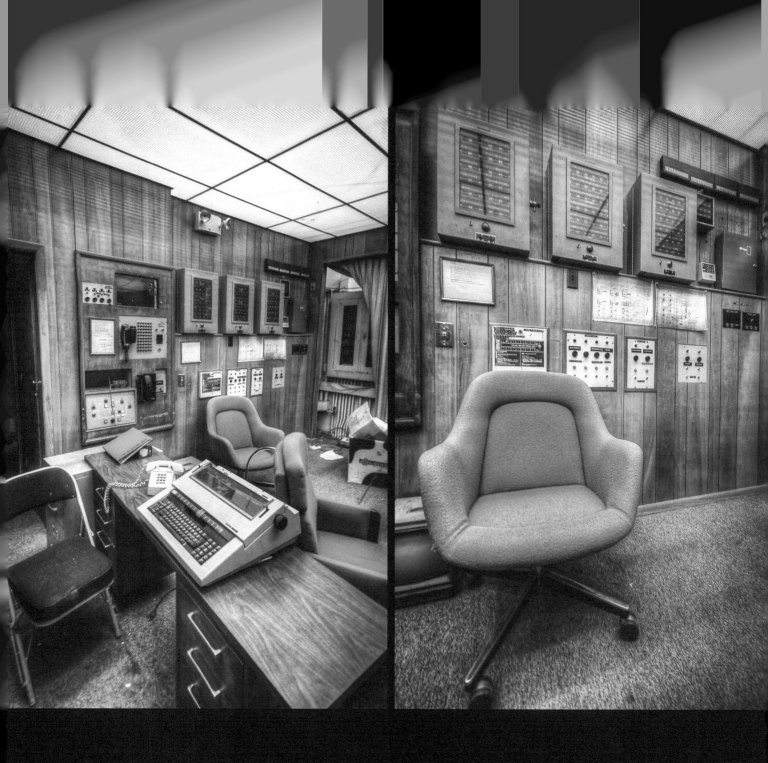

Adjacent to the security checkpoint was a command center for building security and operations.

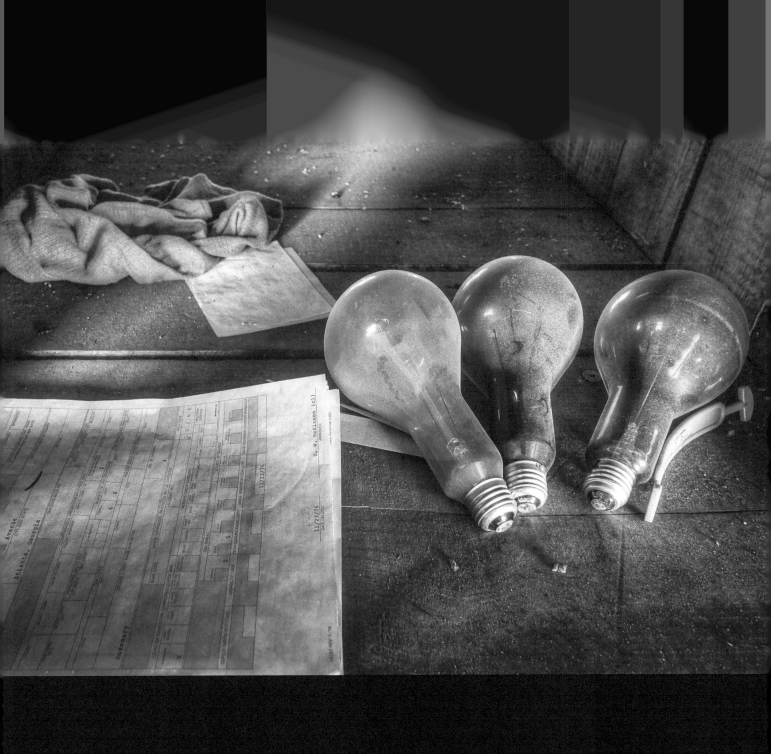

A stack of work orders for various city buildings lay on a shelf in the tower.

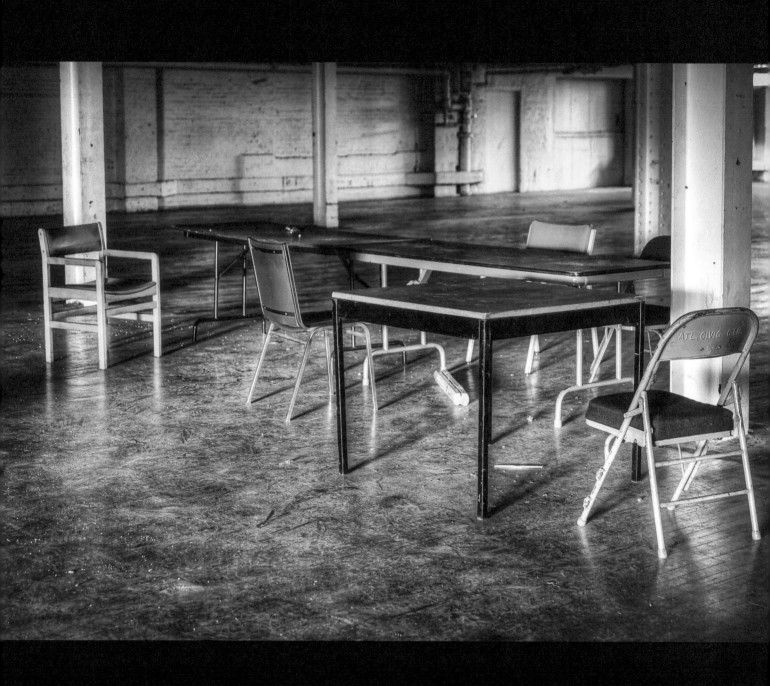

Ground floor of the Exhibition Hall, now part of the North Avenue lower parking area.

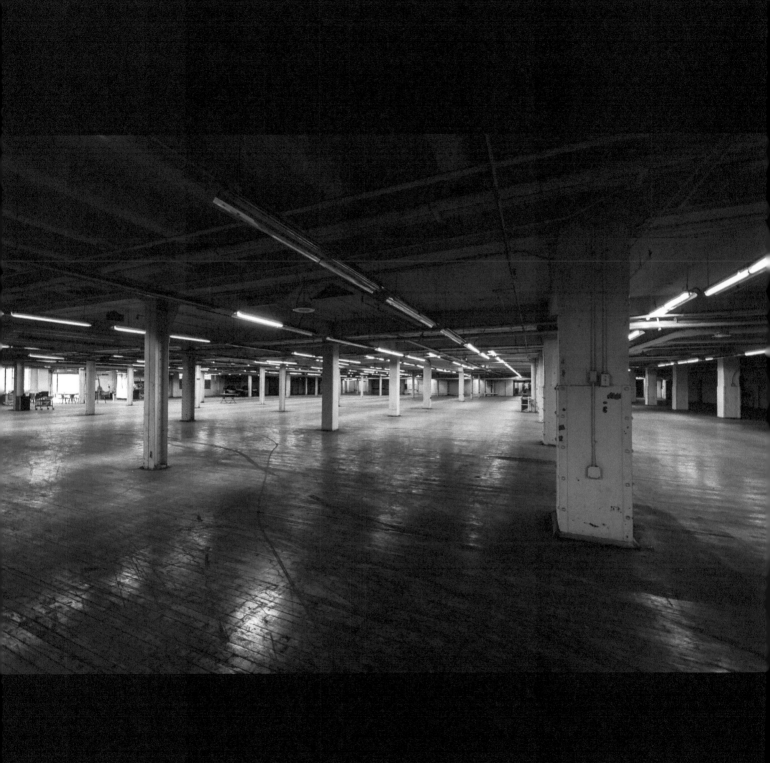

The City of Atlanta only occupied one-third of the 2.1 million square-foot building.

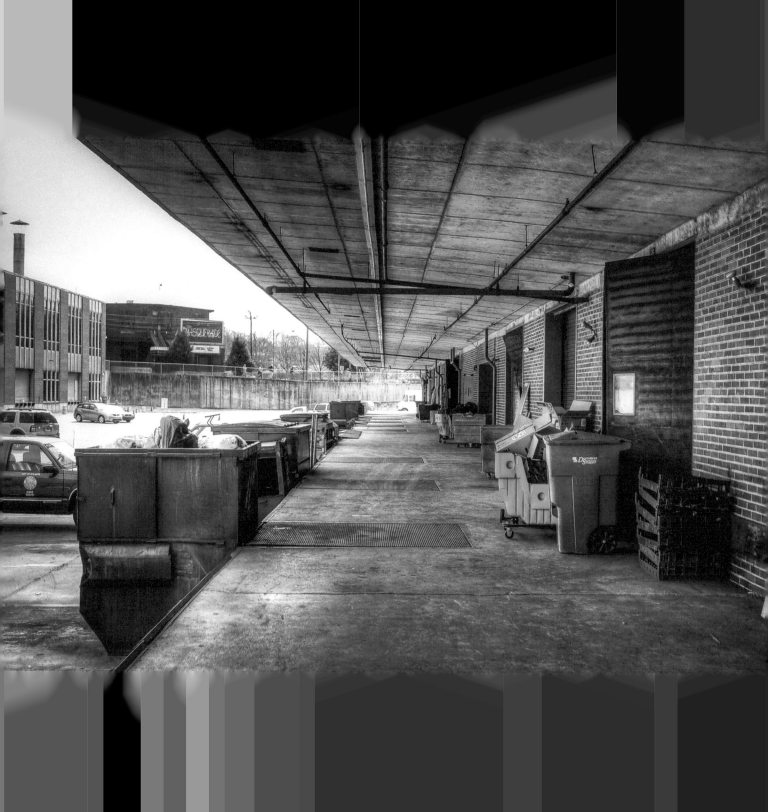

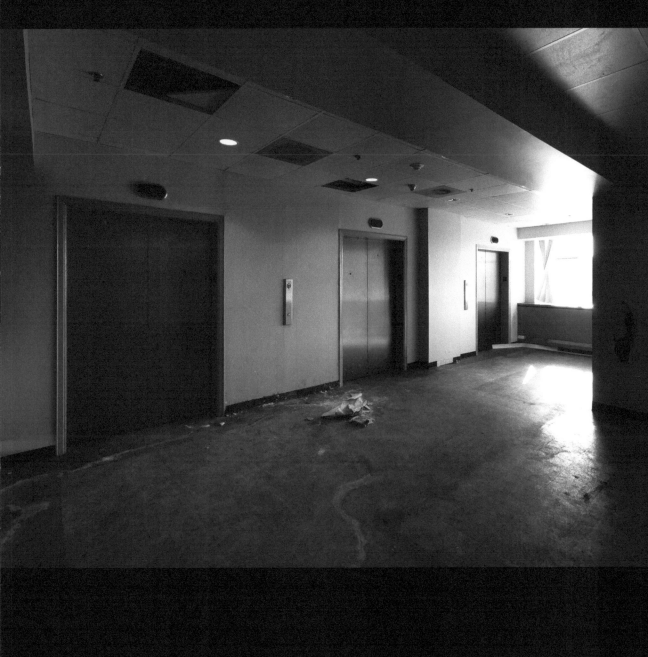

Drop-tile ceilings and modern passenger elevators in the west wing, now part of The Flats

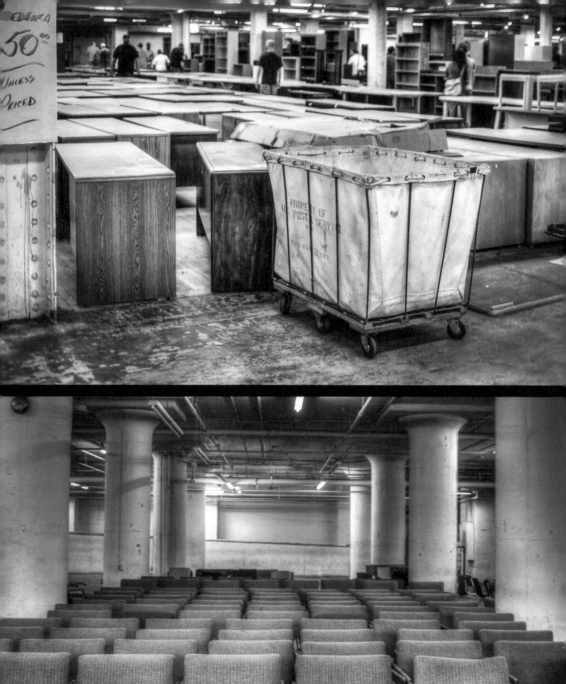
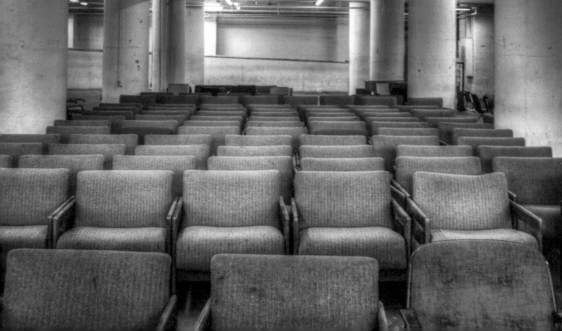

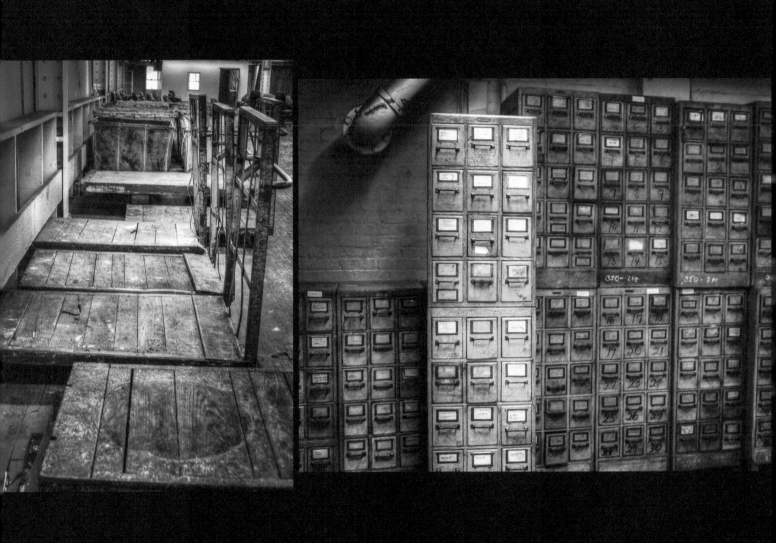

A sampling of odd items made available for sale during the city's liquidation of property from City Hall East.

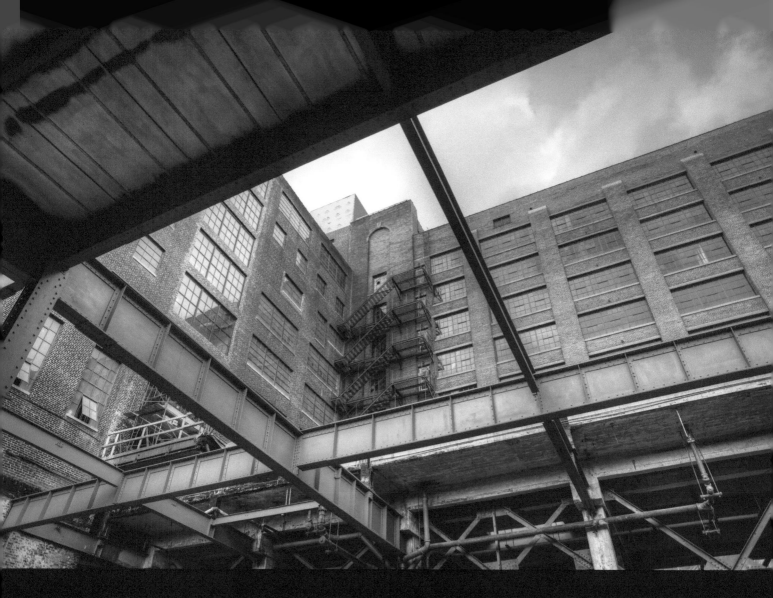

Resurgens: Ponce City Market

By 2011 the building was sold to Jamestown Properties, who put a massive redevelopment plan into motion. Finally, the idea of a mixed-use development began to take shape, as the building was remediated floor by floor to play host to corporate offices, private residences, and public retail and dining destinations. The Central Food Hall and many of the retailers opened for business in the fall of 2015, with more arriving by late 2016. Much like the former springs on which the building purportedly sits, Ponce City Market intends to draw Atlantans back to

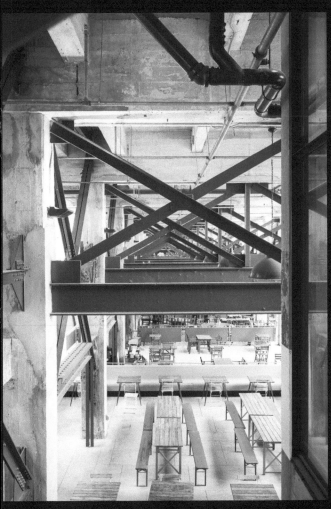

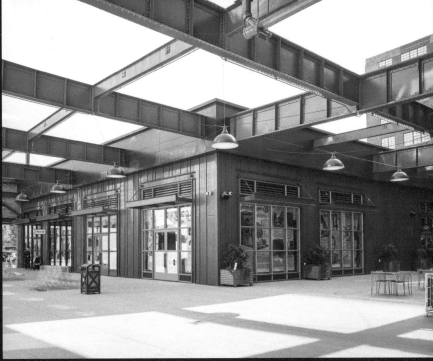

Now completed, the former Exhibition Hall serves host to retail stores, and as patio space for restaurants.

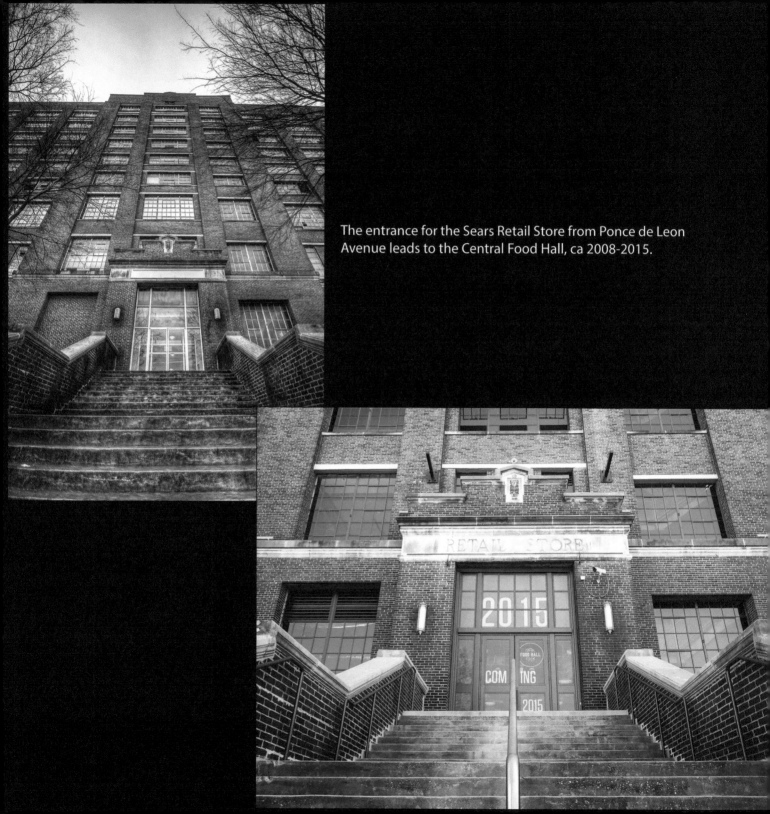

The entrance for the Sears Retail Store from Ponce de Leon Avenue leads to the Central Food Hall, ca 2008-2015.

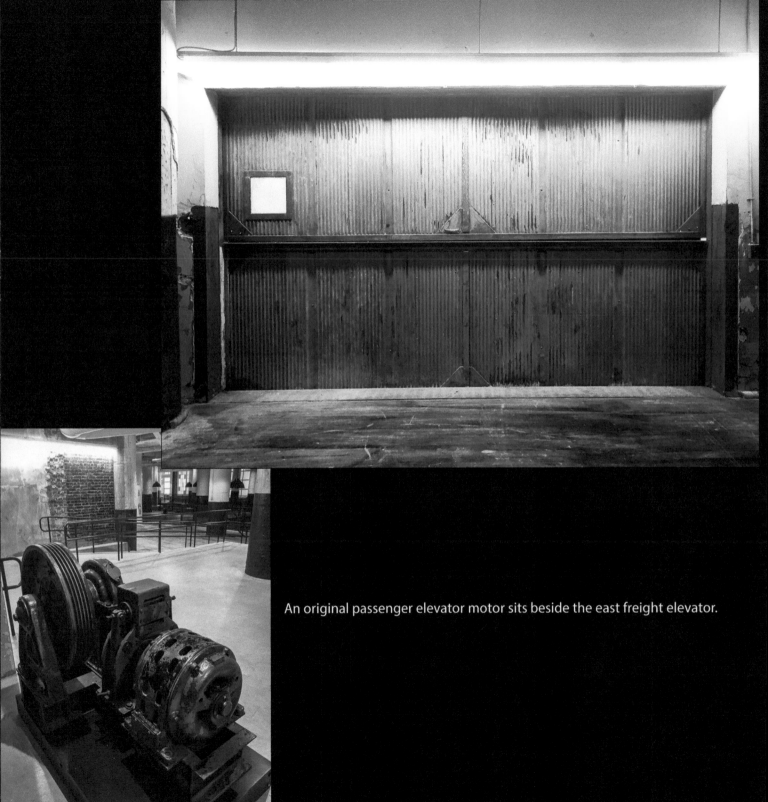

An original passenger elevator motor sits beside the east freight elevator.

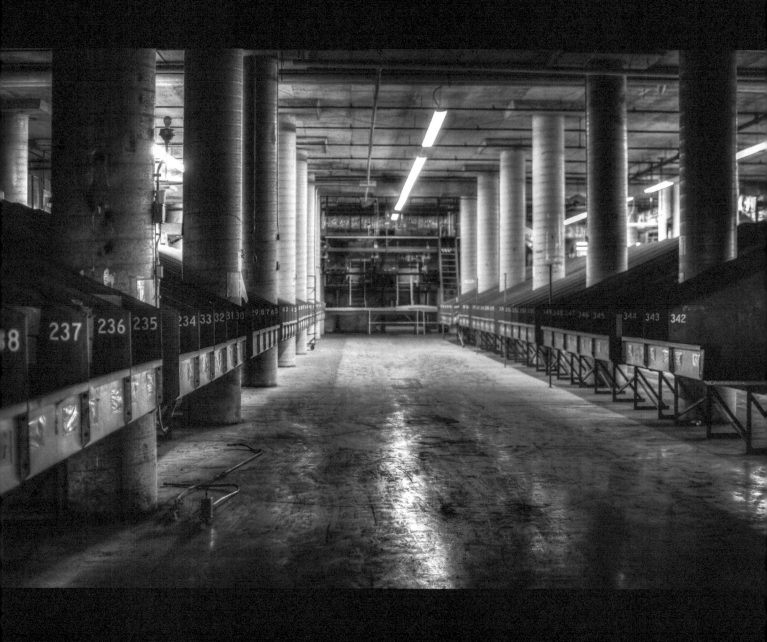

A 9-story annex was constructed on the east side of the building to provide a facility for sorting.

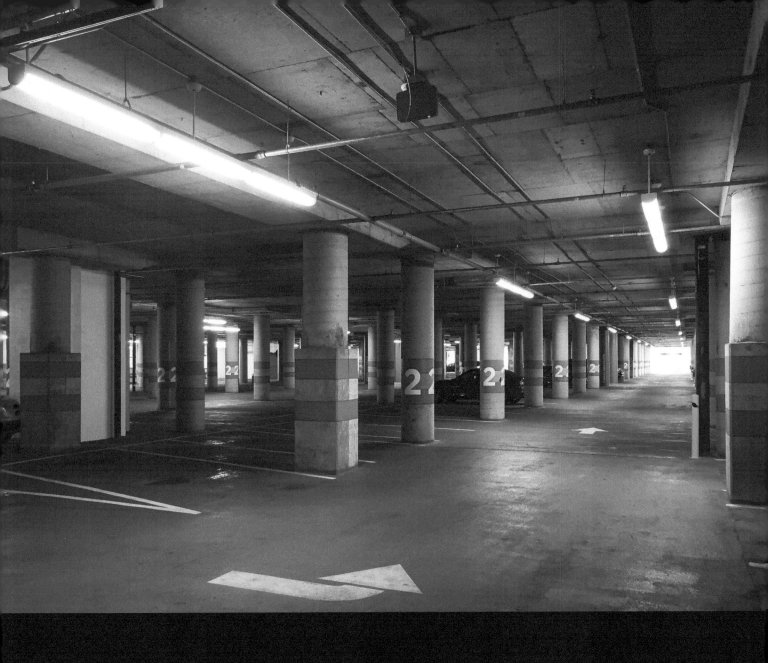

Nearly the entire wing has transitioned in use from holding merchandise to either parking deck or Flats units.

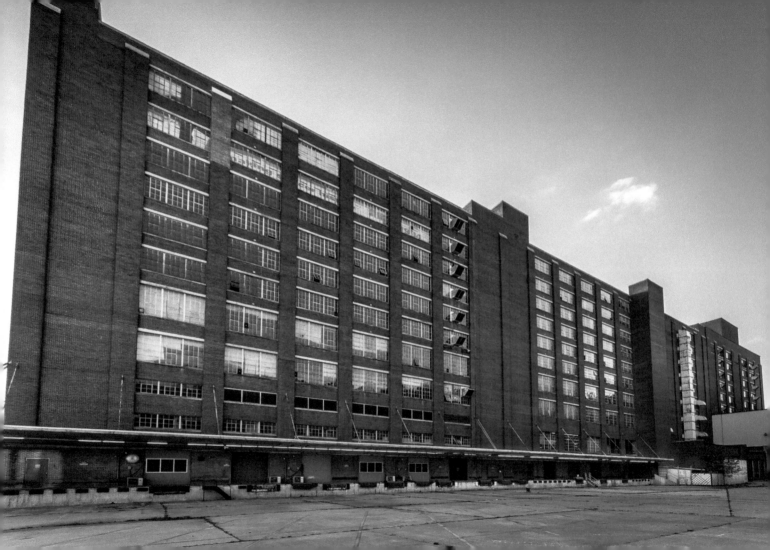

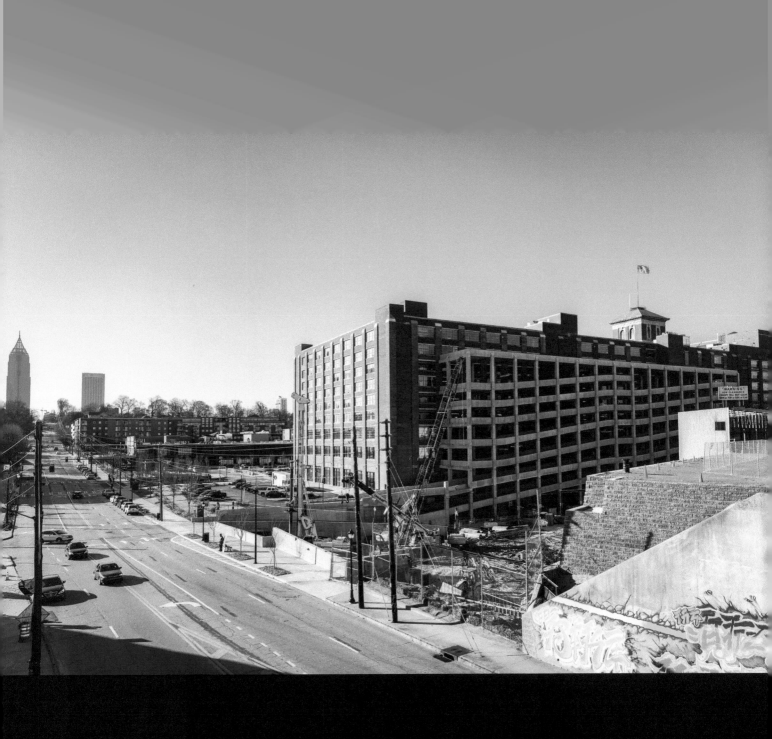

View of progress from the new pedestrian bridge, part of the Eastside Trail of the Atlanta BeltLine, ca 2015

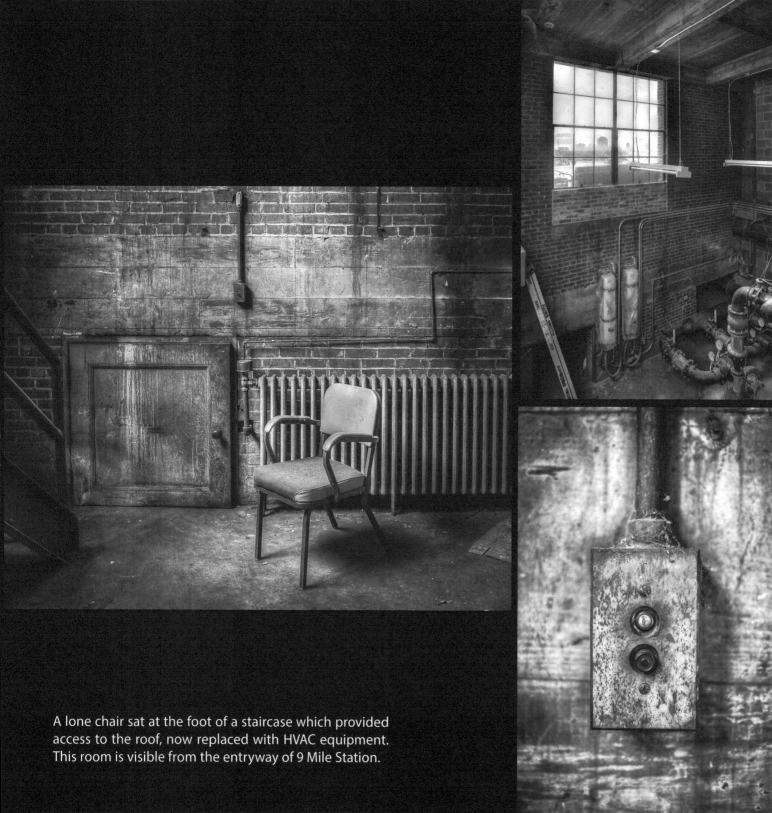

A lone chair sat at the foot of a staircase which provided access to the roof, now replaced with HVAC equipment. This room is visible from the entryway of 9 Mile Station.

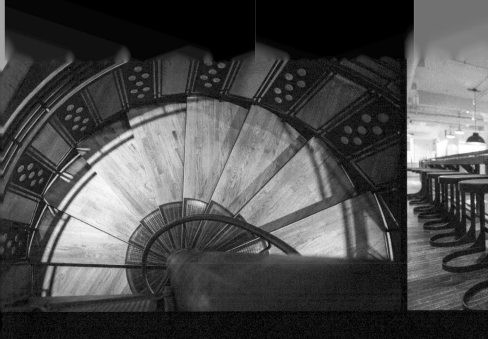
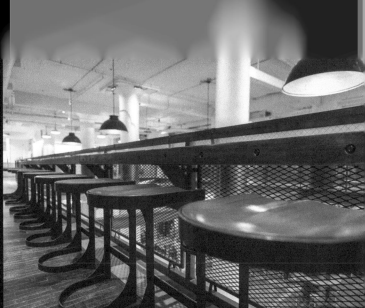

Central Food Hall

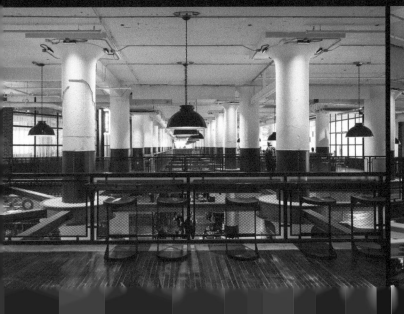
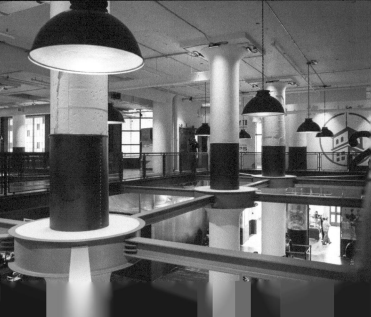

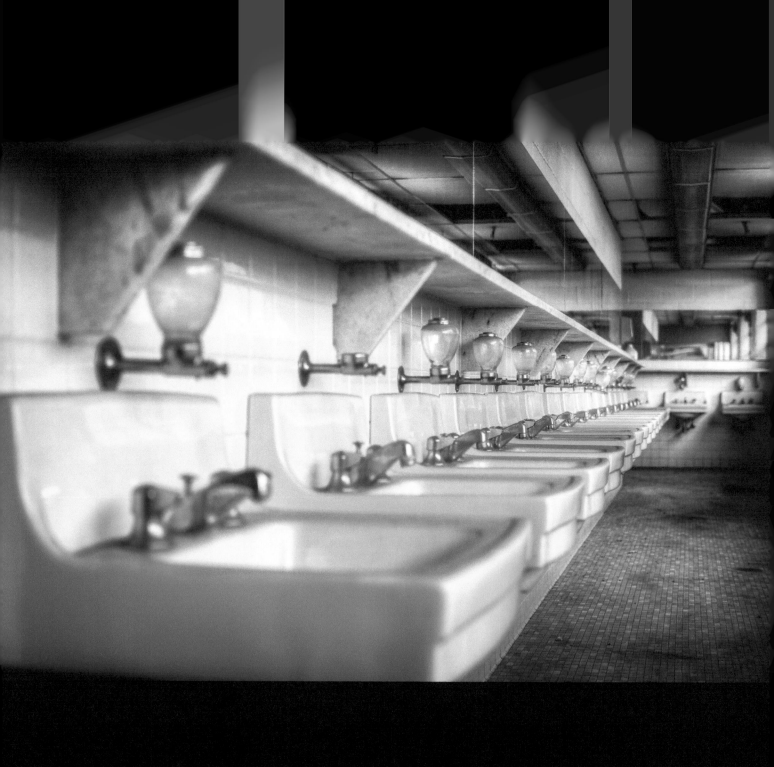

Sinks in a restroom near the sorting room floor, ca 2011

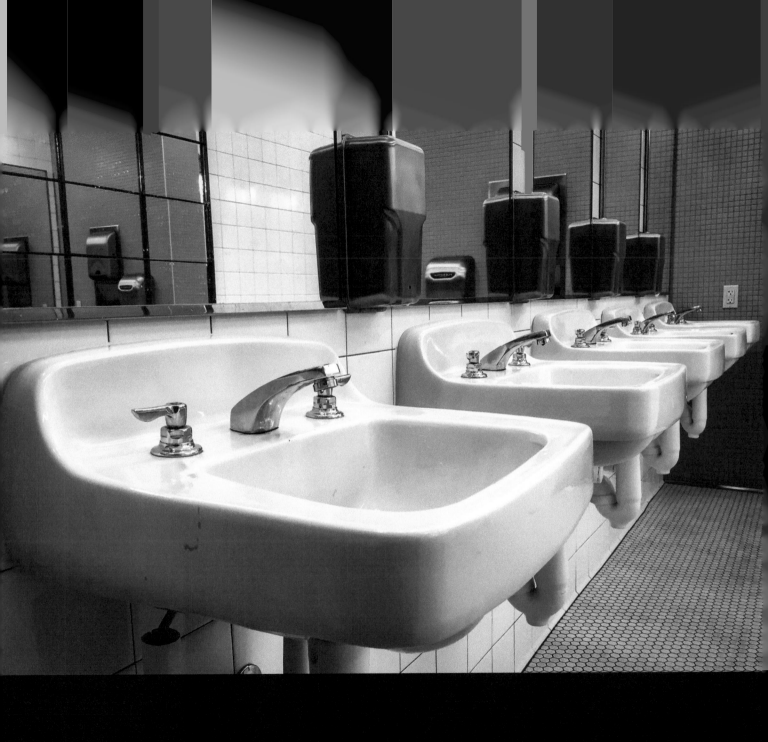

New restroom facilities pay homage to the original fixtures, and decorative mirrors mimic the 3-section windows.

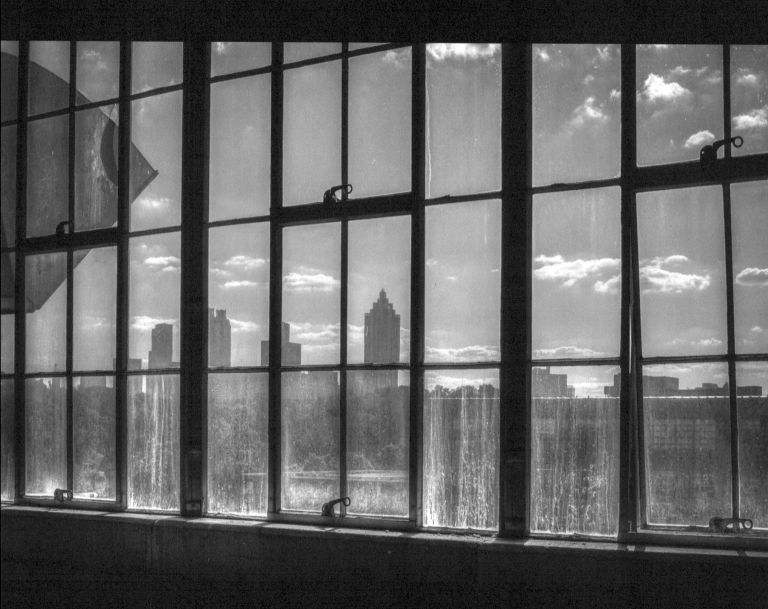

A view of Midtown Atlanta from the eastern wing of the building.

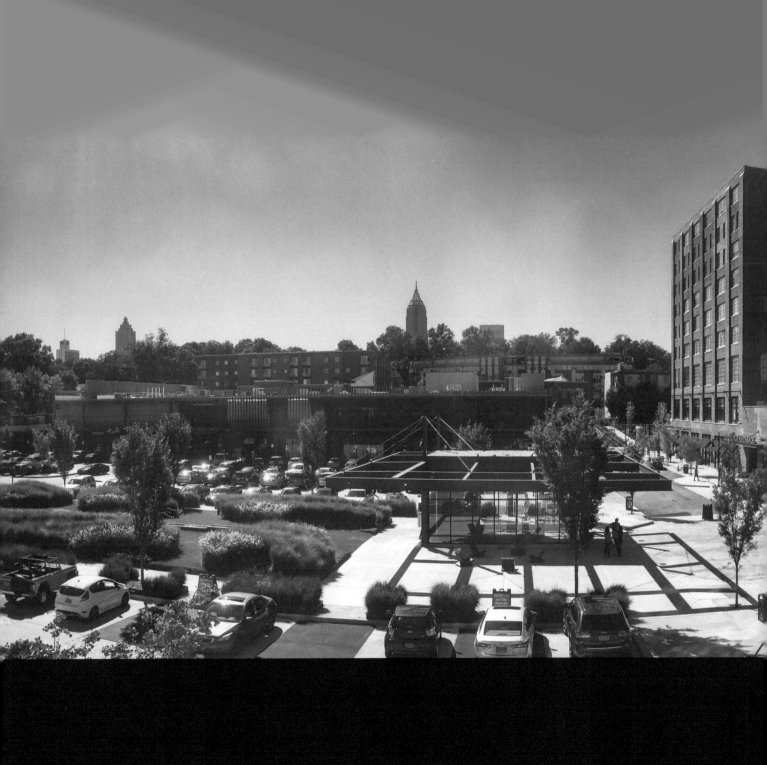

The east wing now overlooks the central parking area, previously below-grade

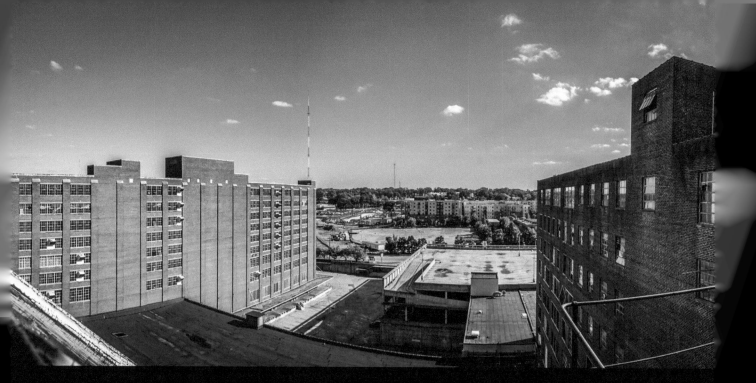

Overlooking progress along the North Avenue parking deck and former Exhibition Hall , ca 2011-2014.

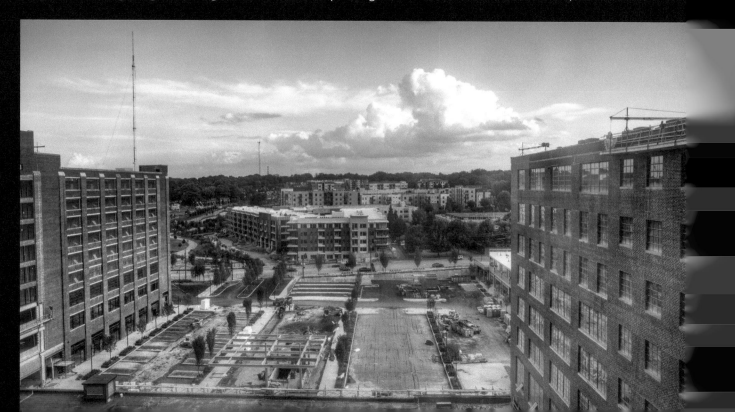

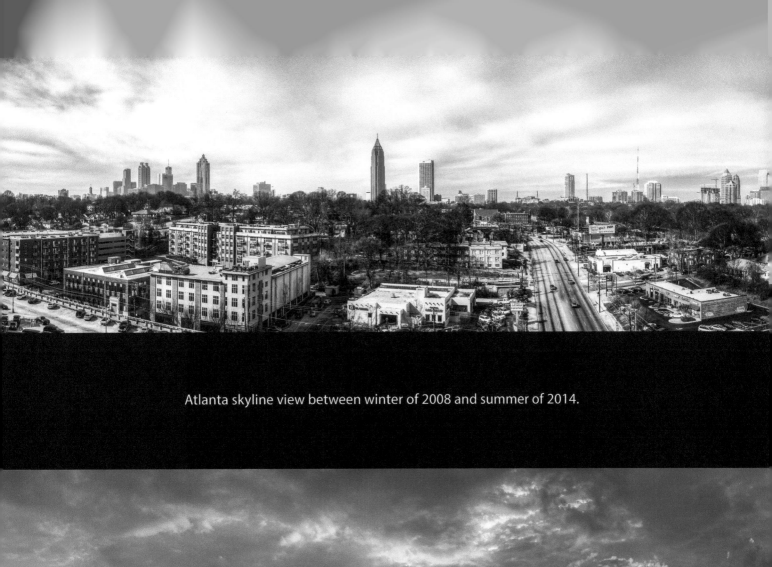

Atlanta skyline view between winter of 2008 and summer of 2014.

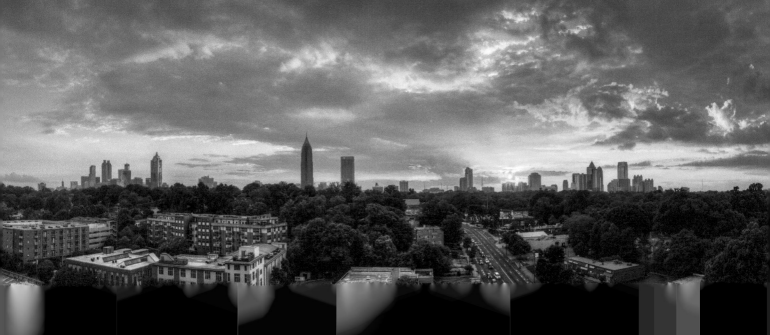

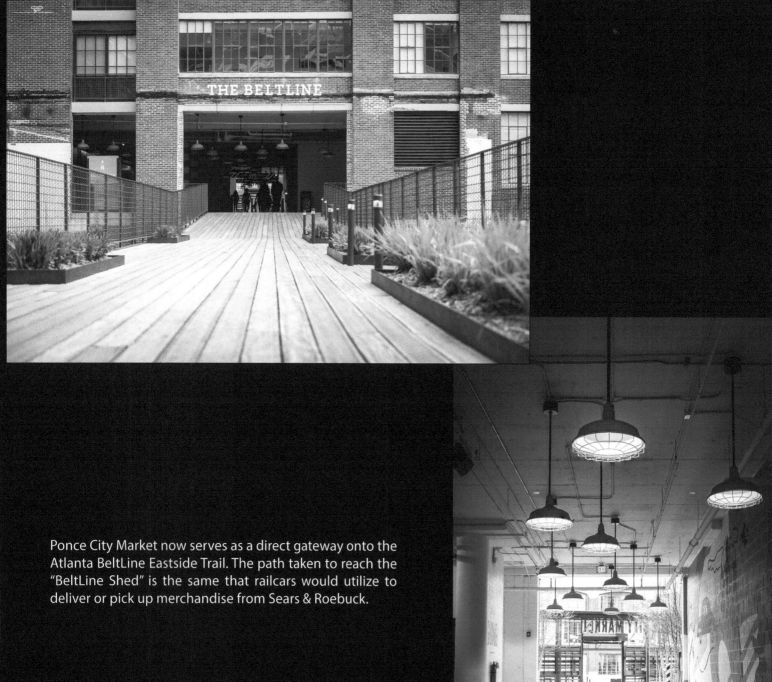

Ponce City Market now serves as a direct gateway onto the Atlanta BeltLine Eastside Trail. The path taken to reach the "BeltLine Shed" is the same that railcars would utilize to deliver or pick up merchandise from Sears & Roebuck.

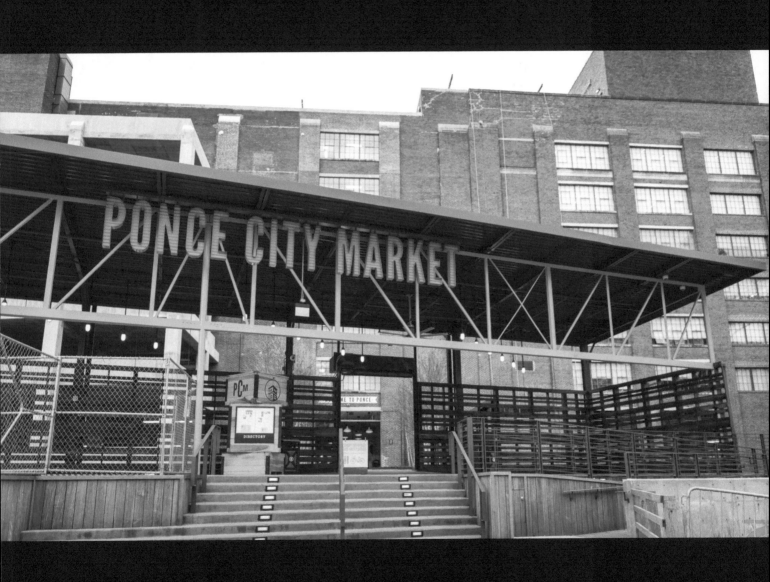

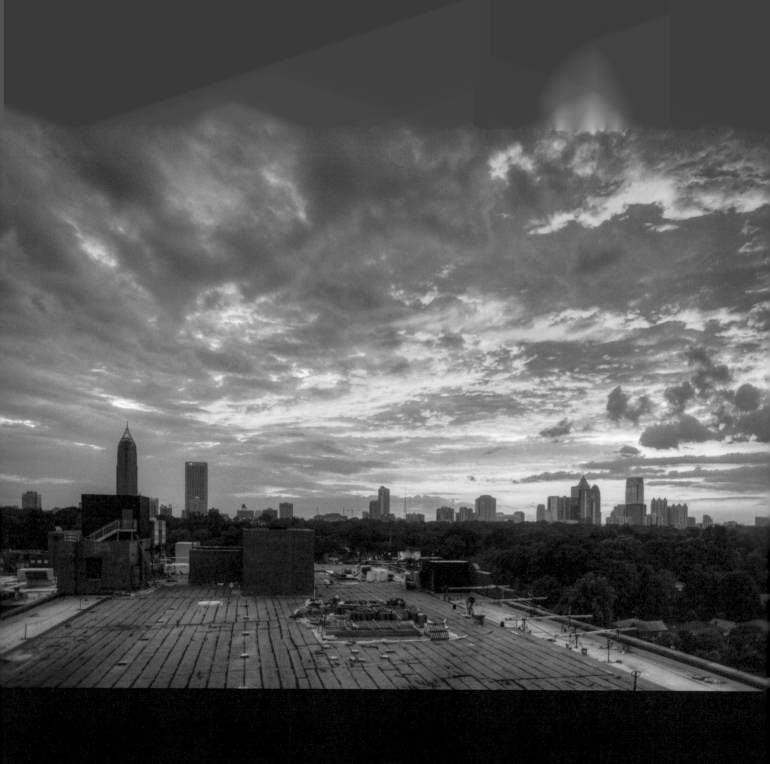

Preparing the roof for the massive Ponce City Market sign, Skyline Park, and 9 Mile Station, ca 2014

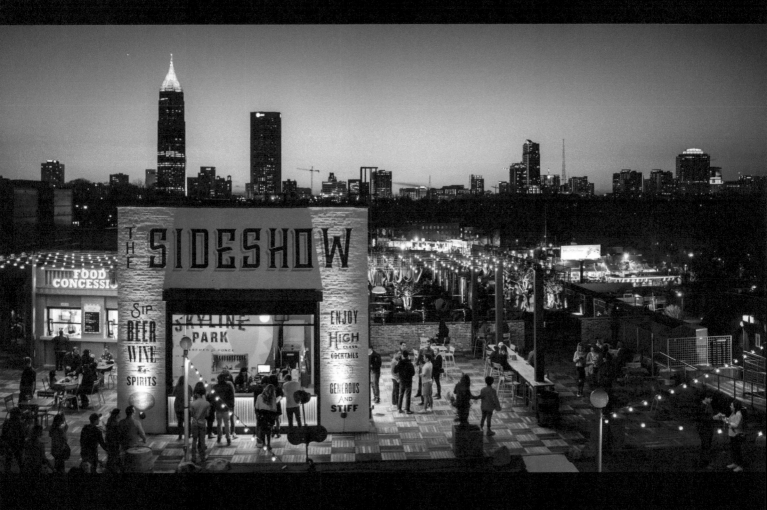

A view of Atlanta from atop the Heege Tower, one of the rides at the completed Skyline Park.

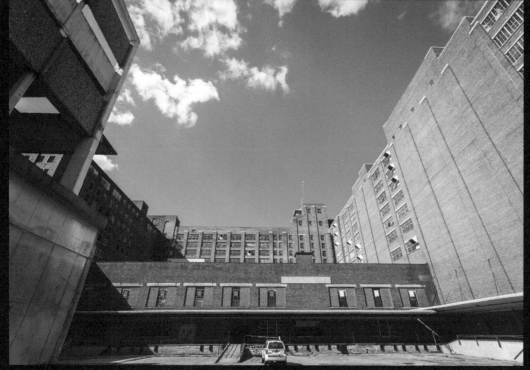

Looking at the former Exhibition Hall and loading docks below-grade from North Avenue, ca 2011.

Nearly-completed market entrance via surface parking, now at-grade with North Avenue, ca 2014.

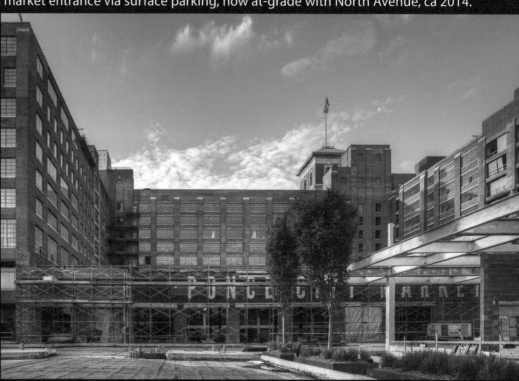

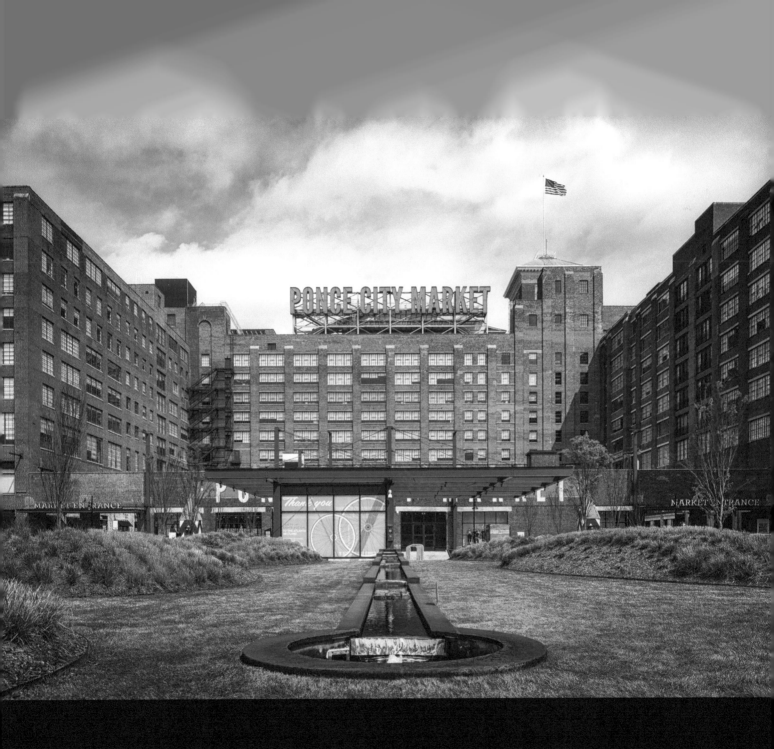

A view of the completed North Avenue market entrance and greenspace, ca 2015. In honor of the SEARS sign that once existed, a similarly-styled lighted sign was added atop the building facing North Avenue and H4WP.

From the Author

"Waking a Leviathan" has been a labor of love to document one of a few recent and successful projects by Atlanta developers to reuse historic spaces within the city. Creation of the photographs in this publication has spanned nearly a decade, from 2008 through 2017, and the better part of a year crafting this journey for others to enjoy as I have.

For more information please contact me at photo@dustingrau.com, find me as @justindustin on Instagram, Flickr, and Twitter, or visit htttp://photography.dustingrau.com

Acknowledgements

To my wife, Amy, for her patience and understanding through my late nights of meticulous editing and near-endless obsession over this project from 2016-2017.

The Morsberger Group, who allowed first access into the building in 2008.

Jamestown Properties, for their continued access to document the many steps of completion since 2011.

Sharon Foster Jones, through her book "Atlanta's Ponce de Leon Avenue: A History" for unknowingly inspiring me to pursue the historic aspect of the Sears building and for filling in many gaps about the history of the area.

Andrew Feiler, fellow photographer and explorer of things forgotten. For insistence on creating a body of work, and his own experience with publication which has been invaluable.

CPSIA information can be obtained
at www.ICGtesting.com
Printed in the USA
BVHW02n0502090718
521094BV00012B/209/P